ANIMALS:
HOW TO DRAW THEM

ANIMALS:
HOW TO DRAW THEM

by Hugh Laidman

PELHAM BOOKS
London

743.69

LA1

First published in America in 1979 by E.P. Dutton, a
Division of Elsevier-Dutton Publishing Co., Inc., New York,
U.S.A.

Published simultaneously in Canada by Clarke, Irwin &
Company Limited, Toronto and Vancouver.

This edition first published in Great Britain by
Pelham Books Ltd.
44 Bedford Square
London WC1B 3DU
1980

ISBN: 0-7207-1289-0

172769

Printed in the U.S.A.

Acknowledgment

This book began in South Africa with the help of Rocco Knobel, Director of National Parks, and under the guidance of Bernard Sargent, South Africa's superb animal artist.

Thanks go to the personnel and animals of the Bronx Zoo, the Cleveland Zoo, the Philadelphia Zoo, Busch Gardens, African Safari, and the Buffalo Museum of Science. Most of all, thanks to the animals, domestic and wild.

for Jennifer

Contents

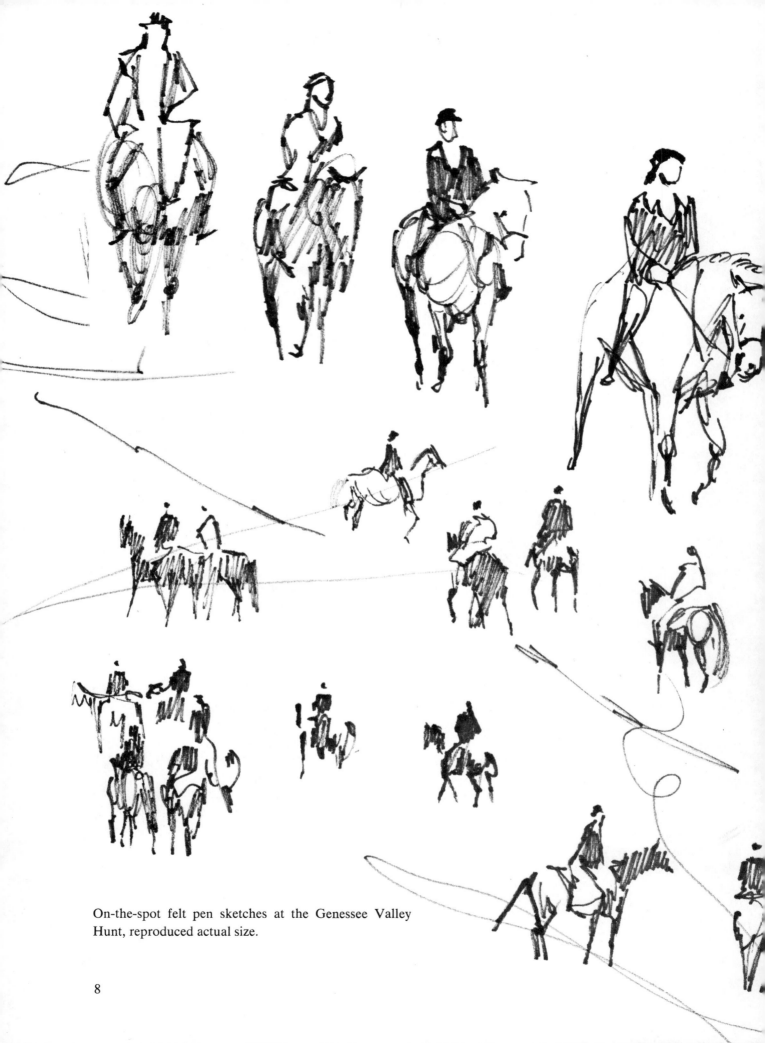

On-the-spot felt pen sketches at the Genessee Valley
Hunt, reproduced actual size.

There is no singularly "right" or "wrong" way to draw animals. Three great American artists, Edward Hicks, John James Audubon, and Frederick Remington, differed widely in their approaches, yet all three left us memorable paintings of animals.

Hicks's paintings were essentially copied, in whole or in part, from paintings and engravings of the day. Audubon moved a step closer to the real thing. Not content with observing animals in their wild state, he shot them, hung them on wires—sometimes in positions that would have been impossible for the animal while alive—and painted them magnificently.

Remington went still further. He believed that only through close observation of the living animal could an artist make a creditable painting of it. He spent much of his time living with the cowboys and the military in the American West, drawing hundreds of on-the-spot sketches of the animals. These, in turn, became the foundation of his great works.

This book suggests that you avoid the "swipe" method employed by Hicks, and the "shoot-'em-string-'em-up" procedure of Audubon, and follow more closely the on-the-spot observation practices of Remington. Hicks's copying system generally leads to disaster for the would-be artist while Audubon's method is impractical in today's society. Remington's approach to the drawing of animals is not only practical but singularly effective and enjoyable.

Readily available to the artist who would draw animals are hundreds of reproductions of great paintings of today and yesterday. These should be studied by the aspiring animal artist. Stuffed animals are also excellent objects for study, as are statues of animals. Seeing how someone else handled the problem of depicting a particular animal helps to develop your own approach to technique and materials. You will want, too, to study photographs of animals, both those you yourself have taken and those taken by professional animal photographers.

These methods of study combined with hundreds of on-the-spot sketches lead to good animal drawing. But knowledge and study are, in themselves, not enough. The artist does not just draw a cat or a dog or a chimpanzee. He must draw with a feeling for the animal. This he develops through long hours of observation of its habits, its movements, and its personality. As the artist watches the animal in motion and at rest, he makes notes and sketches his observations. The more he learns about the animal, the better able he is to draw it.

A knowledge of animal anatomy can be most helpful, but such knowledge is best if it is absorbed gradually. An overemphasis on anatomy in the early stages of learning to draw animals can be frustrating and discouraging. Once you are sketching with relative proficiency, it is time enough to look more deeply into what goes on underneath the surface.

If you become well grounded in anatomy, you must then avoid the pitfall of letting your knowledge become too obvious in your final drawings.

There is no magic formula for the making of a good animal artist. Hours of hard, and frequently frustrating, work go into the completion of a good animal drawing. Not everyone can make it—only those who appreciate the animal kingdom and have a talent for keen observation along with the ability, developed through intelligent practice, to translate their observations of a living creature into graphic form.

Knowing What to Look For

You will more easily understand the likenesses and differences in animals if you know something about how the animal functions.

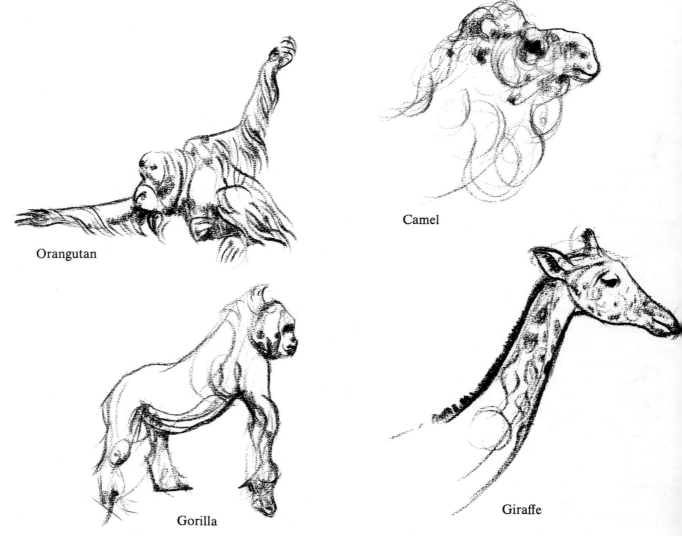

Orangutan

Camel

Gorilla

Giraffe

The orangutan spends a great part of its life in trees. Its arms are long and its hands strong and well adapted for grasping branches. The gorilla spends considerably more time on the ground. Its arms are also long and its hands powerful, but it has adapted its body to surface locomotion. The human, standing erect, has proportionately much stronger legs than either of these fellow primates.

Study the camel and the giraffe. The basic structure and typical stance of the animal do more to identify it than does the surface pattern or detail. Viewed from a distance, where color, humps, or long neck might not be distinguishable, there still would be little difficulty in identification. Consider how quickly you can identify someone a great distance away even though you can't tell the color of his eyes or the shape of his features. In drawing animals, think first about the overall form or structure and the identifying stance, not the detail.

10

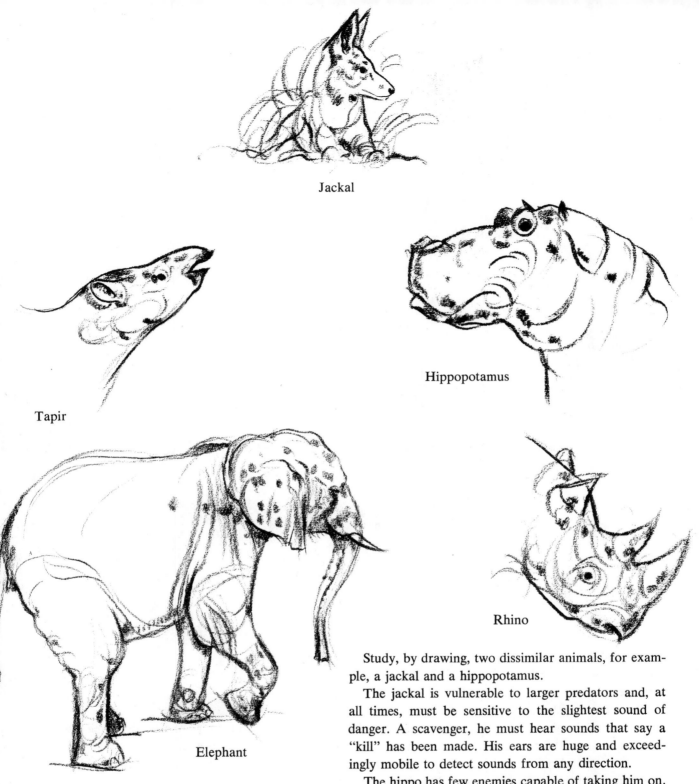

Jackal

Tapir

Hippopotamus

Rhino

Elephant

Study, by drawing, two dissimilar animals, for example, a jackal and a hippopotamus.

The jackal is vulnerable to larger predators and, at all times, must be sensitive to the slightest sound of danger. A scavenger, he must hear sounds that say a "kill" has been made. His ears are huge and exceedingly mobile to detect sounds from any direction.

The hippo has few enemies capable of taking him on. Noise may disturb him, but sound is of no great importance to him. His ears are tiny compared to his bulky head. The hippo, who spends much of his time partially submerged, has a mobile set of nostrils that act as an efficient snorkling device.

The ears of the rhino, who also has few natural enemies except man, are relatively large. His hearing ability probably compensates for his poor eyesight.

A tapir's snout has been compared to an elephant's trunk. Knowing this, you can draw the tapir's head or the elephant's head more intelligently. By drawing you increase your ability to draw, but aimless, thoughtless sketching will produce little that is worthwhile. When you draw with knowledge and direction, you begin to draw with a feeling for the animal. That's what it's all about.

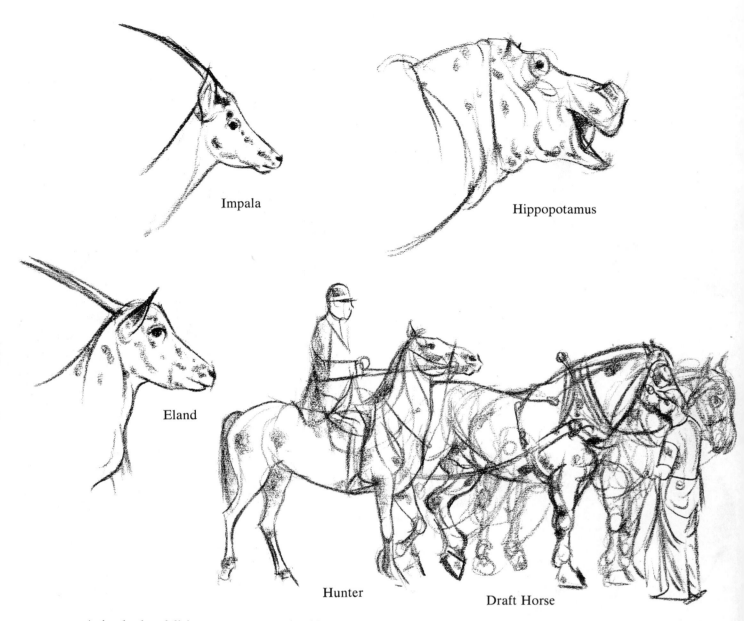

Impala

Hippopotamus

Eland

Hunter

Draft Horse

Animals that fall into a common scientific classification may vary radically in appearance. Consider the antelope.

The smallest antelope in South Africa is the blue duiker, with a height of 13 inches. The impala weighs between 130 and 160 pounds and has an average height of 3 feet. A black wildebeest can reach 4 feet at the shoulder. Elands weigh between 1,200 and 2,000 pounds and can reach a height of 6 feet. The impala can leap a distance of 35 feet and clear a height of 10 feet. The eland's gymnastic abilities more closely resemble those of a highly active cow.

The artist looks for and puts into his drawing the details that indicate these differences. The hippo is at home in mud and water, the antelope, in the veldt. The heads alone say this loud and clear.

Unlike the wide range of size and shape found in the antelope family, horses usually look like horses, even though varieties have been bred for special purposes over the centuries. The hunter, although no slouch when it comes to athletic ability, has a form slightly but noticeably different from the draft horse. The carriage of the head, the action of the body, the way the legs hold the body, say action and spirit. The heavy neck and the tremendous shoulder development of the draft horse give a feeling of power. Putting the hunter in a horse pull harness could never disguise the fact that he was not cut out for the job of heavy hauling.

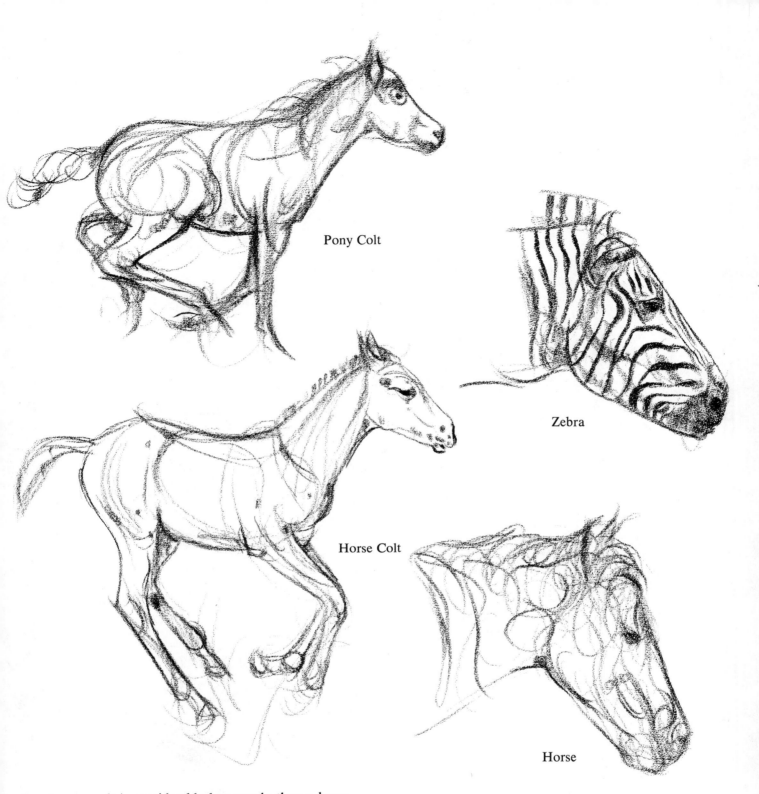

Pony Colt

Zebra

Horse Colt

Horse

A pony colt is considerably less gangly than a horse colt. Both have rag mop tails, but the differences become apparent to the artist as he observes and sketches. The business of drawing serves to imprint facts in the artist's mind. If you limit your observation to the study of others' works or photographs, you will fail to develop as an artist and if you copy slavishly, the sharpness of your own perceptions could be fatally dulled.

At first glance the zebra and the horse appear very much alike. A zebra, minus stripes, might be mistaken for a small horse. Closer observation shows differences. It is these less obvious differences that the artist looks for.

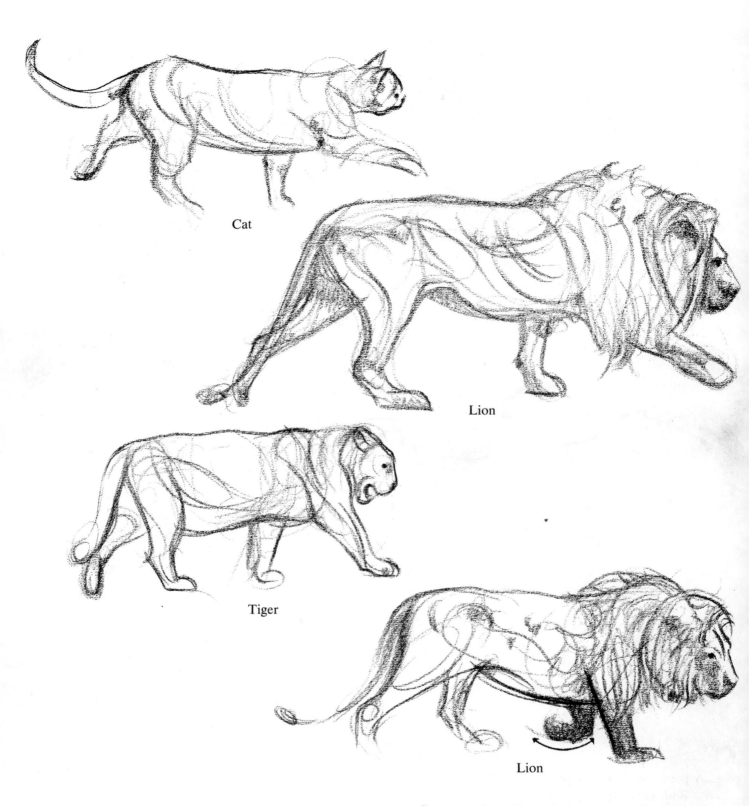

Cat

Lion

Tiger

Lion

Study the motion of a domestic cat. Compare the similar motion of a tiger. Here the tiger's stripes are missing to emphasize the fact that it is not the stripes that identify the animal as a tiger. It is the action and the attitude of its body, head, and neck.

Compare the action of the lion in the same relative position. Along with studying the fundamental structure and design of every animal, the artist must look for and learn to capture on paper the details peculiar to that animal. Here the foot on the lion's foreleg seems to swing as on a well oiled hinge.

14

Young Chimp

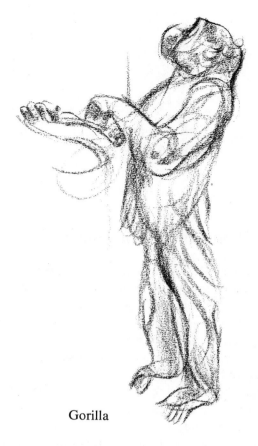

Gorilla

Young Gorilla

It is quite within the capabilities of the gorilla, with the aid of a prop, to simulate a human posture.

In various stages of growth and development animals adopt different postures and actions. The baby chimp and the baby gorilla have a distinctive set of actions that say immediately that they are immature. Their actions are surprisingly similar to those of a human child.

Drawing animals, like drawing anything else, is more of a mental exercise than an exercise of finger dexterity. When you make a mistake, you will have to check your observations to analyze where you went wrong.

A Word about Photography

Today's animal artist has a useful tool in the camera. It can be invaluable in the study of animals. Overreliance on photographs, however, can spell disaster.

There is a right way and a wrong way to use photographs. The right method is to work from many photographs of the animal in many positions. In the case of black-and-white or color prints, spread the photographs around the drawing board so that all of them can be seen at a glance. You may be drawing a front view, but while you are, you can study the side view, the back view, and any number of other views that will aid you in your drawing. Merely copying a photograph does little to aid you in becoming a good animal artist.

Another method of working from photographs is to use transparencies (slides) in projection. Movies of the animal's action are also excellent references.

Along with photography, the artist must observe and sketch the animal whenever possible. Notes that he takes on the spot will make possible much more intelligent sketches from photographs.

Happily for the artist-photographer, most fast-lensed cameras have a shallow depth of focus. This limitation of the camera makes it possible to keep the animal in focus while fencing and bars are completely blurred. It is almost as though the camera has shot around or through the cage.

Film for a camera is rated at varied speeds of sensitivity. This simply means that a film speed of 64 ASA, regular Ektachrome, is slower than a film speed of 160 ASA, high-speed Ektachrome. About a third as much light is necessary to expose the high-speed Ektachrome as the regular Ektachrome. High-speed film is a necessity for the artist working in dim or poorly lighted situations. There is the option of using flash to increase the amount of light, but both regulations and common sense sometimes discourage the use of auxilliary light.

Most cameras suitable for shooting animals in action have shutter speed, ranging from one second to one thousandth of a second. Somewhere between the two extremes is a speed effective in "stopping" the animal's action. A ponderous elephant's motion might be caught easily with a shutter speed of $\frac{1}{100}$th of a second, but a photograph of a lively ape might need a shutter speed of $\frac{1}{500}$ of a second to get more than a blur on the film.

The artist taking photographs of animals will find that he needs a higher film speed than that which is commonly available. The answer, though seemingly technical, is simple. The cameraman loads his camera with high-speed film, Ektachrome 160, and sets his camera for a film speed of 400. He therefore will need about one third less light to shoot. When developing the film, he informs the processor that he has shot the 160 film at 400 ASA. The processor then can develop the film accordingly. This can only be done, however, with the Ektachrome film.

The advantages of color film over black-and-white are many, even if most of the finished drawings are black-and-white. Somehow, more of the essence of the animal comes through to you in the color picture. Color transparencies may be enlarged through projection to huge sizes, allowing you to study otherwise obscure detail. In addition, the slides are relatively inexpensive.

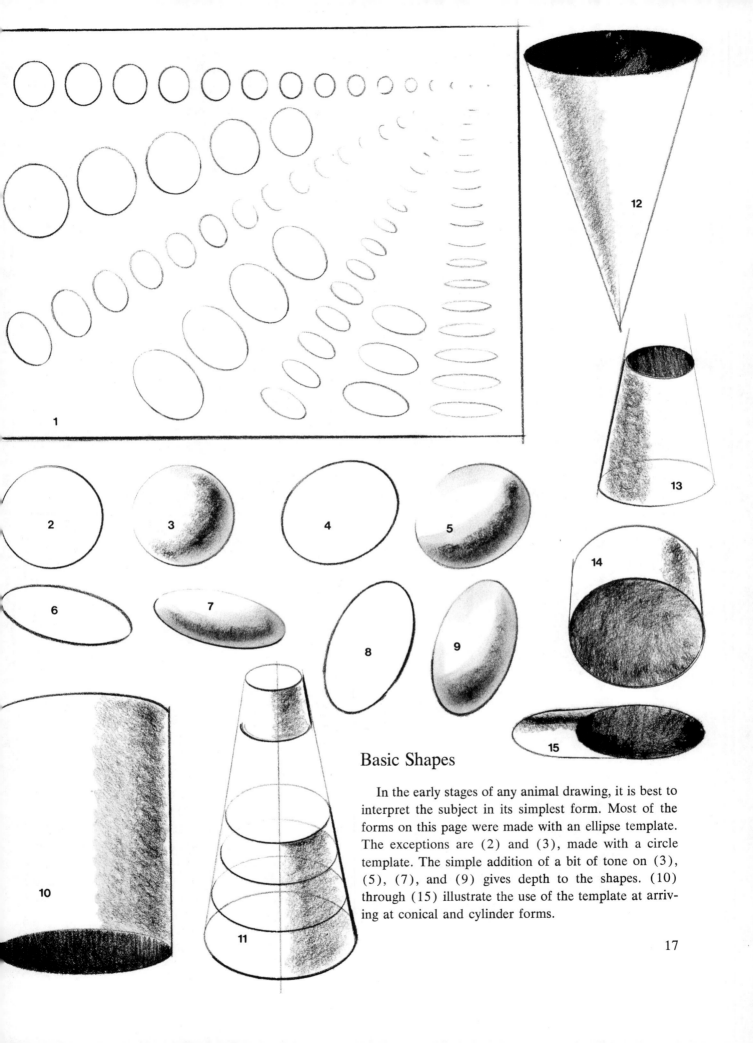

Basic Shapes

In the early stages of any animal drawing, it is best to interpret the subject in its simplest form. Most of the forms on this page were made with an ellipse template. The exceptions are (2) and (3), made with a circle template. The simple addition of a bit of tone on (3), (5), (7), and (9) gives depth to the shapes. (10) through (15) illustrate the use of the template at arriving at conical and cylinder forms.

17

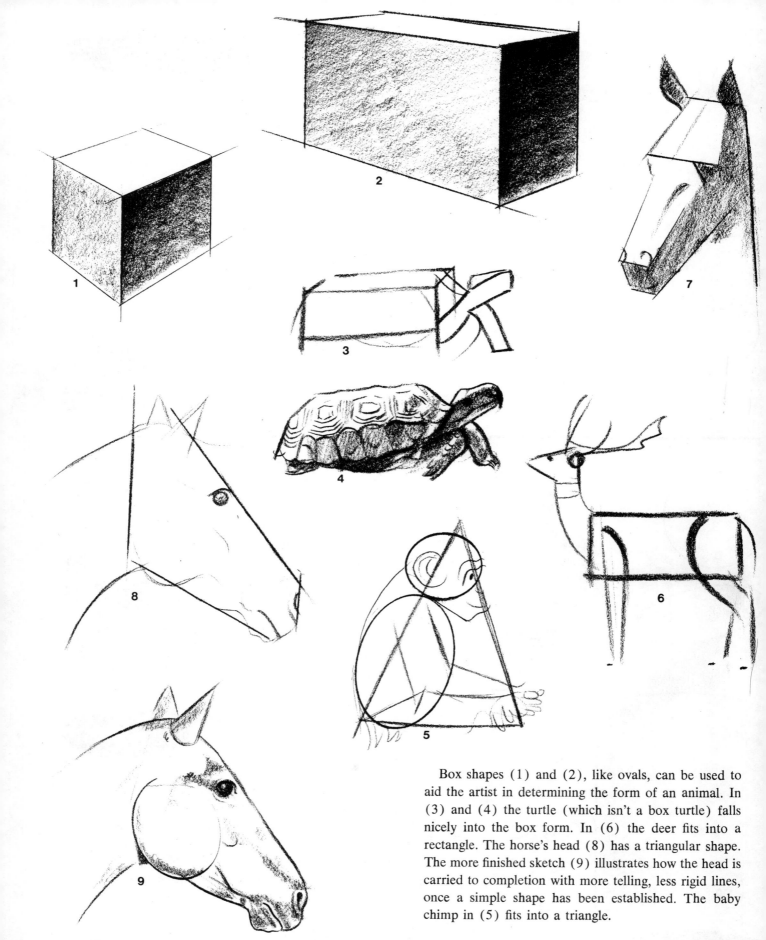

Box shapes (1) and (2), like ovals, can be used to aid the artist in determining the form of an animal. In (3) and (4) the turtle (which isn't a box turtle) falls nicely into the box form. In (6) the deer fits into a rectangle. The horse's head (8) has a triangular shape. The more finished sketch (9) illustrates how the head is carried to completion with more telling, less rigid lines, once a simple shape has been established. The baby chimp in (5) fits into a triangle.

All the drawings of the animals on this page, with the exception of (7), began as simple ovals. (a) shows the dish shape conformation of the grizzly's head as compared to the shape of the polar bear's head (b).

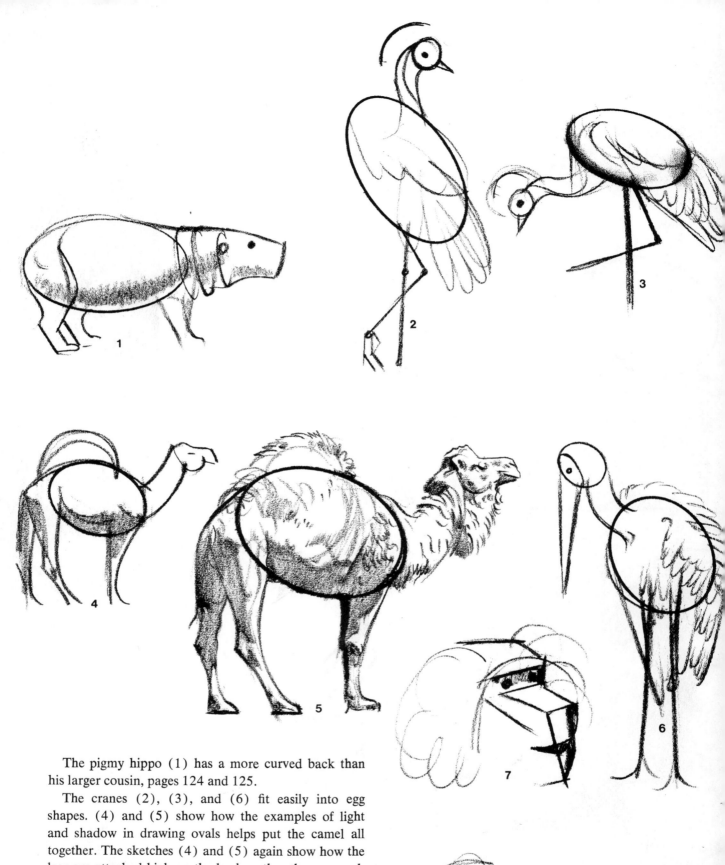

The pigmy hippo (1) has a more curved back than his larger cousin, pages 124 and 125.

The cranes (2), (3), and (6) fit easily into egg shapes. (4) and (5) show how the examples of light and shadow in drawing ovals helps put the camel all together. The sketches (4) and (5) again show how the legs are attached high on the back, rather than on each lower corner. In (7) and (8), the first stages of drawing a mandrill, both the ellipse and triangle have been employed.

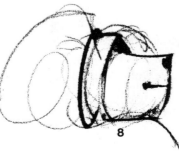

(1) employs the cylinder form for the initial drawing of the horse's body. In (2) the drawing is brought to a greater degree of completion. (3) and (4) not only employ ovals and cylinder shapes, but again illustrate the proper place to attach the limbs, not on the lower corners of the body, but high on the top section of the horse. In (5) the head of the goat (6) has been thought of as a cone. (7) is a use of the cylinder shape as a starting point.

21

Drawing from Statuary

In the early stages of learning to draw animals, carvings, figurines, and sculpture, because they are stationary, can be used to advantage. Many such three-dimensional art pieces are available for viewing in any good art gallery. These are infinitely more instructive than two-dimensional repoductions. They provide an excellent way to study other artists' interpretations of animal forms. Certainly there is no such animal as (1), (2), or (3), but the execution makes the animal believable. Both (4) and (5) get more true feeling of the animal than an every-hair-in-place drawing.

Draw the statues from varied angles.

The horses in (6) are those in the Trevi fountain in Rome. The horse in (7) is a sketch of a living animal waiting near the fountain. (8), (9), and (10) are different approaches to the same sketch. The sculptor of (11) must have worked from a dead lion, lately out of a spectacle in the Colosseum. The overweight Lochinvar with the horse with claws and beak (12) has a more exciting appearance than any photographic likeness.

The material used for the sculpture may, in some cases, dictate the final form of the piece. The elephant statue (13) was in marble. The tail of the elephant is therefore considerably heavier than in life.

22

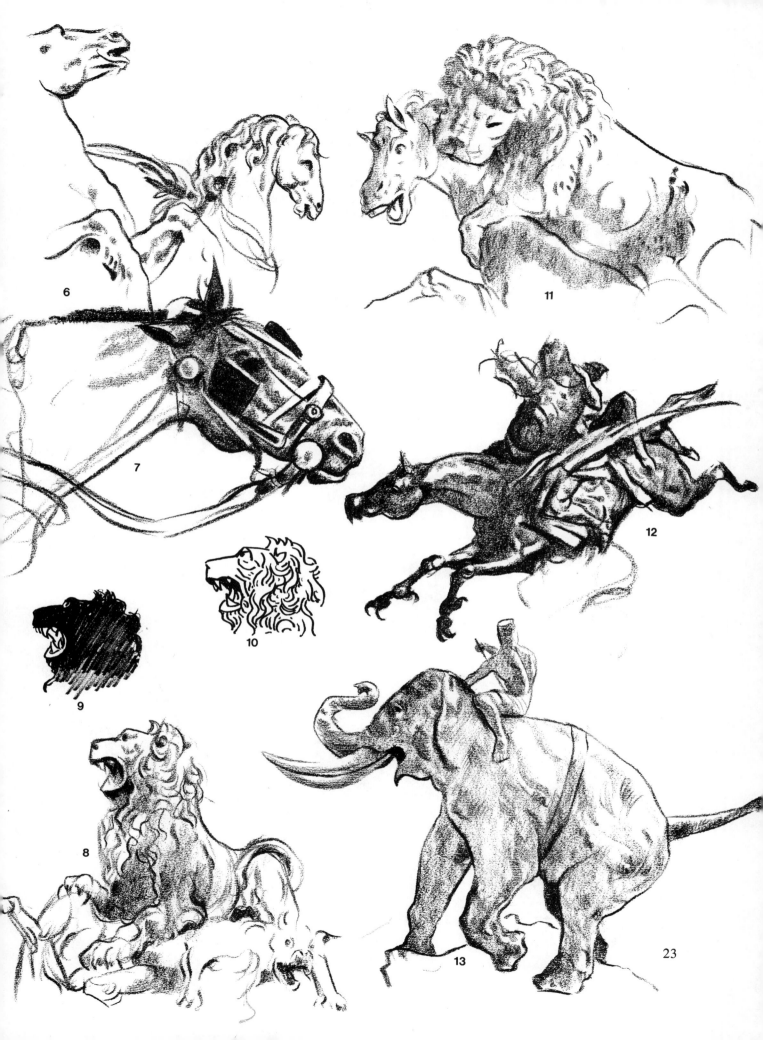

6

7

9

10

8

11

12

13

23

Drawing from Stuffed Animals

An excellent way to become acquainted with animal shapes and attitudes is through the study of stuffed animals. Although the artist is at the mercy of the taxidermist's expertise, in the case of the skunk, there were obvious benefits.

Step (1) uses a couple of ovals to begin. (2) continues into finer definition. (3) concentrates on the familiar markings of the animal.

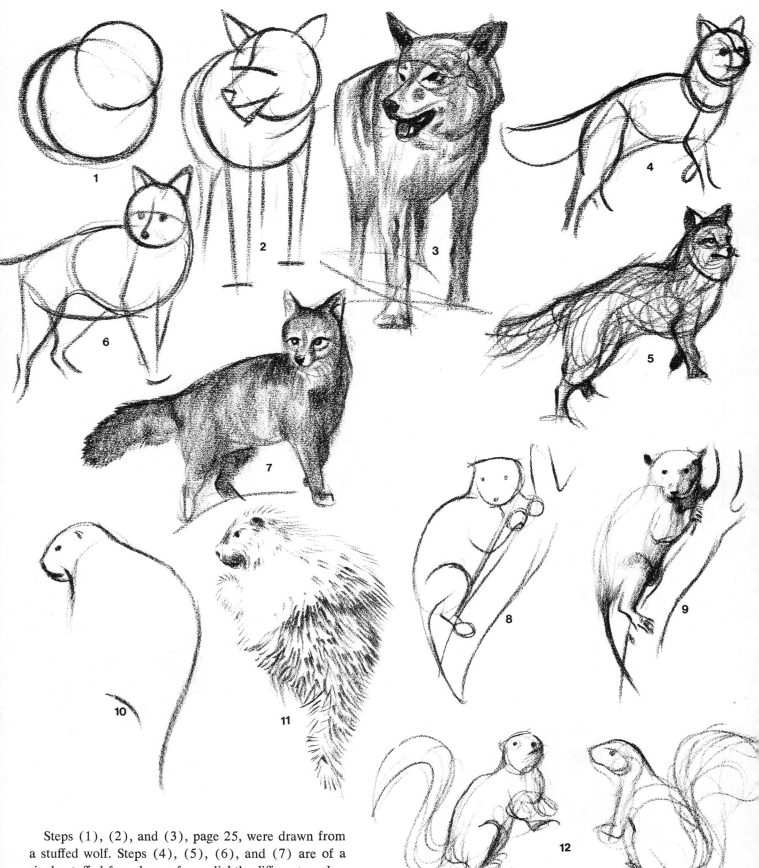

Steps (1), (2), and (3), page 25, were drawn from a stuffed wolf. Steps (4), (5), (6), and (7) are of a single stuffed fox, drawn from slightly different angles. (8) through (12) are quick sketchbook notes.

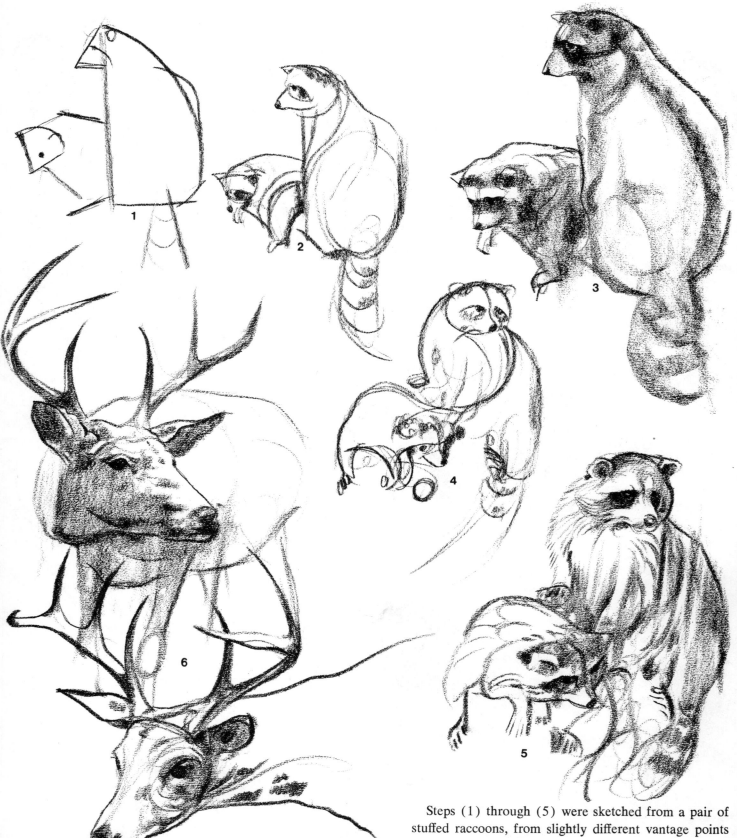

Steps (1) through (5) were sketched from a pair of stuffed raccoons, from slightly different vantage points but at the same eye level.

In the case of the Virginia deer (6), the top sketch was made from a sitting position, while the bottom sketch was drawn from a different spot while standing.

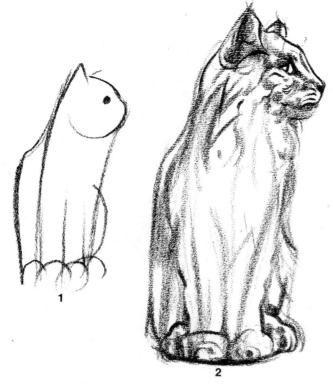

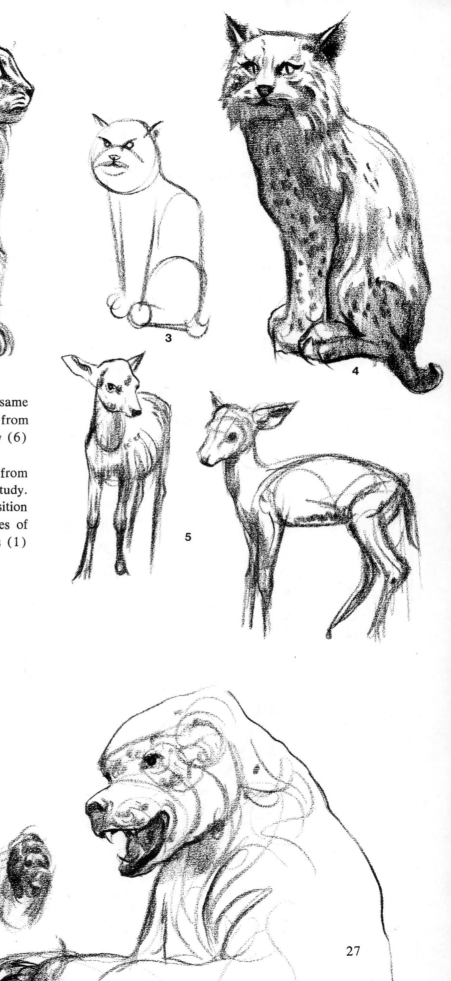

The bobcats (1), (2), (3), and (4) are the same stuffed cat. The fauns (5) were merely sketched from different vantage points. The earless, stuffed grizzly (6) is one and the same bear.

The purpose of drawing any stuffed animal first from one spot, then another, is to give the artist time to study. What the artist observes in a drawing from one position helps him in drawing from the next spot. Features of the bobcat seen from the vantage point in sketches (1) and (2) help in drawing sketches (3) and (4).

27

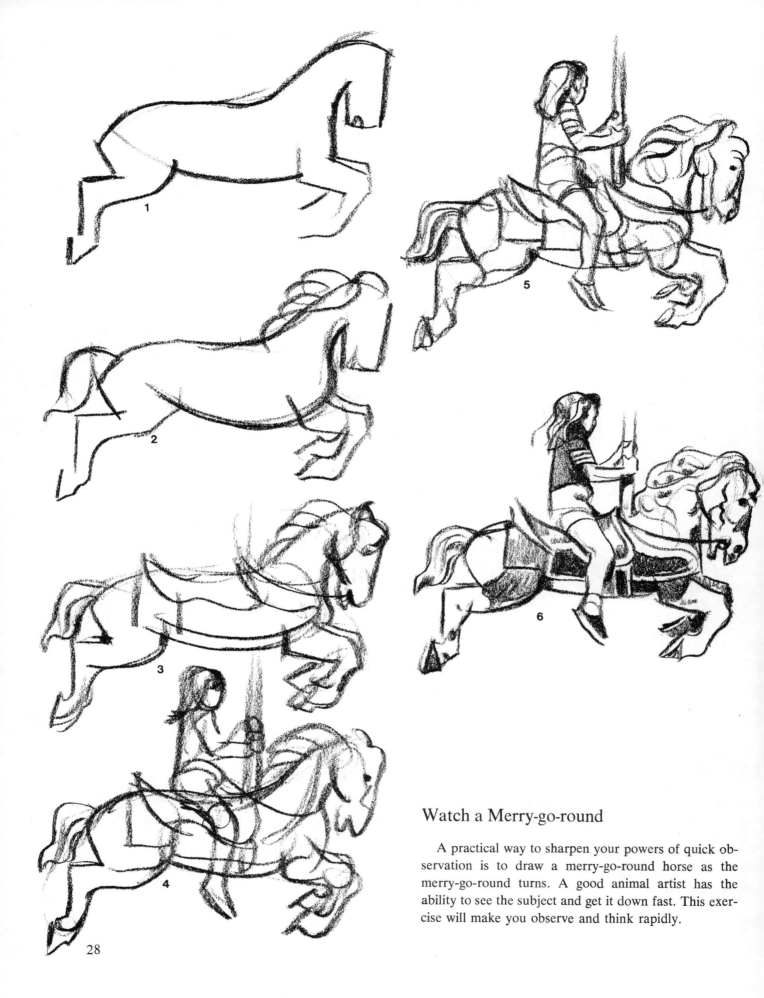

Watch a Merry-go-round

A practical way to sharpen your powers of quick observation is to draw a merry-go-round horse as the merry-go-round turns. A good animal artist has the ability to see the subject and get it down fast. This exercise will make you observe and think rapidly.

28

. . . Or a Circus

A circus, either in actual performance or during the
off season, is a great place to practice quick sketching.

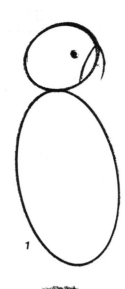

Birds

Birds, particularly those with strong, distinctive features, are relatively easier to draw than four-legged animals. It's wise to practice drawing a few birds before you try to draw other live animals. This does not imply that anyone can draw birds, but rather that the birds used here for practice lend themselves to the basic shapes shown on pages 17 through 21. A further advantage in drawing birds is their habit of continually posturing.

If you wish to make a deeper study of birds, you should learn their anatomy and the way it compares to that of other animals, but here you are trying only to get little practice with not particularly difficult subjects.

The toucan is a good subject. Beginning with the simple oval forms (1), try a scribbling technique (2). Simple flat tone is a helpful approach (3). Bring any one of these starts to the relative stage of completion shown in (4).

The aracaries (5) through (10) follow similar procedure, but have a considerably more fluid line. The line drawing (7) points up this feature of the bird.

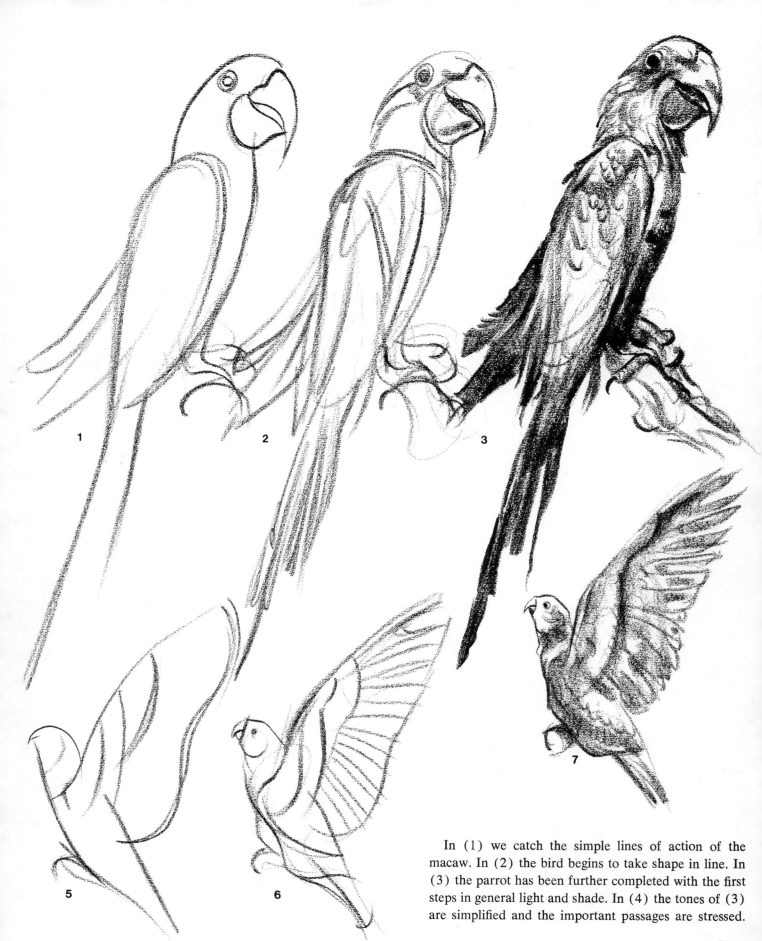

In (1) we catch the simple lines of action of the macaw. In (2) the bird begins to take shape in line. In (3) the parrot has been further completed with the first steps in general light and shade. In (4) the tones of (3) are simplified and the important passages are stressed.

The aim of (5) is to catch the action of the smaller parrot in as few lines as possible. This is done by drawing many beginnings and correcting line after line on the original drawing or, using tracing paper, and by making one drawing on top of the next, in each instance getting closer and closer to the feeling desired.

Once the simple design of (5) is well under control, steps (6) and (7) follow.

Try the same progressive steps with (8), (9), (10), and (11).

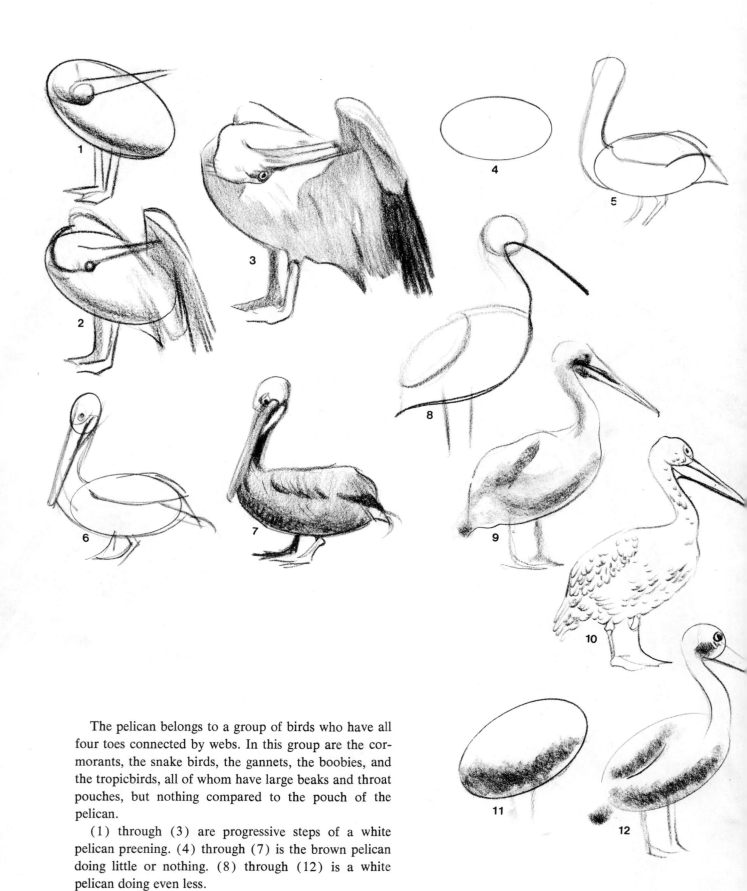

The pelican belongs to a group of birds who have all four toes connected by webs. In this group are the cormorants, the snake birds, the gannets, the boobies, and the tropicbirds, all of whom have large beaks and throat pouches, but nothing compared to the pouch of the pelican.

(1) through (3) are progressive steps of a white pelican preening. (4) through (7) is the brown pelican doing little or nothing. (8) through (12) is a white pelican doing even less.

34

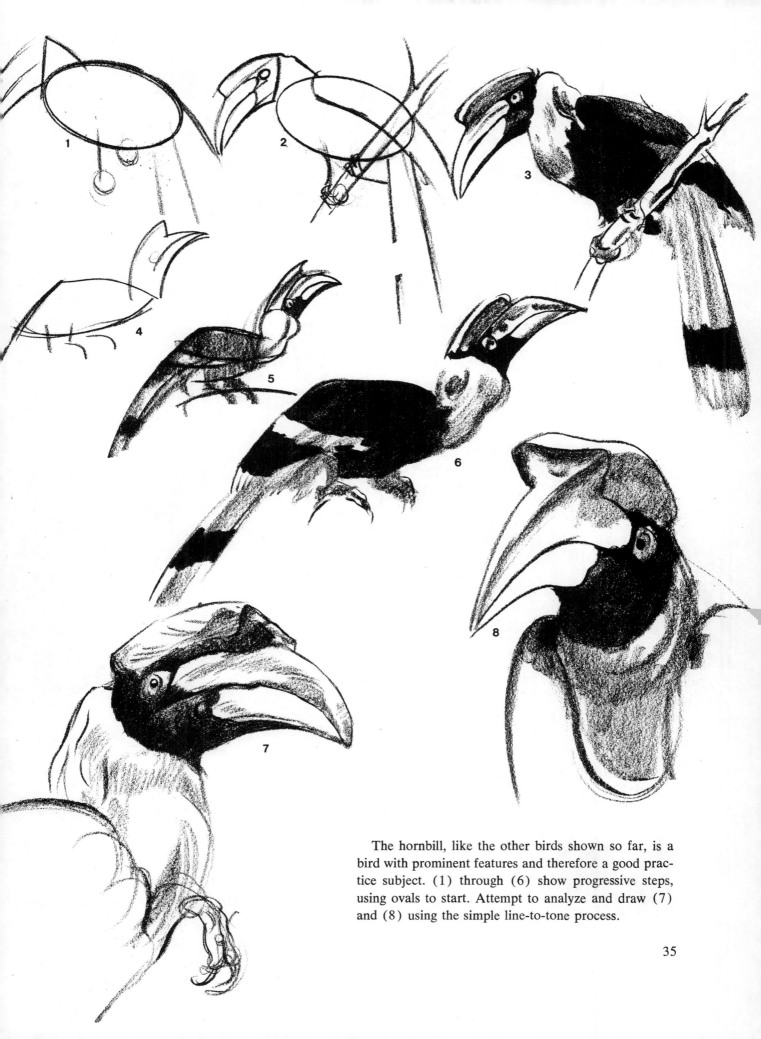

The hornbill, like the other birds shown so far, is a bird with prominent features and therefore a good practice subject. (1) through (6) show progressive steps, using ovals to start. Attempt to analyze and draw (7) and (8) using the simple line-to-tone process.

35

The king vulture is an ideal subject for practice drawing. Although for ages man has looked down upon the vulture, its value as an efficient sanitation department is beginning to be recognized. It may appear complicated at first, from some angles—(3), (6), (9), and (12)—but it can be simplified in the initial stages of drawings —(1), (2), (4), (5), (7), (8), (10), and (11).

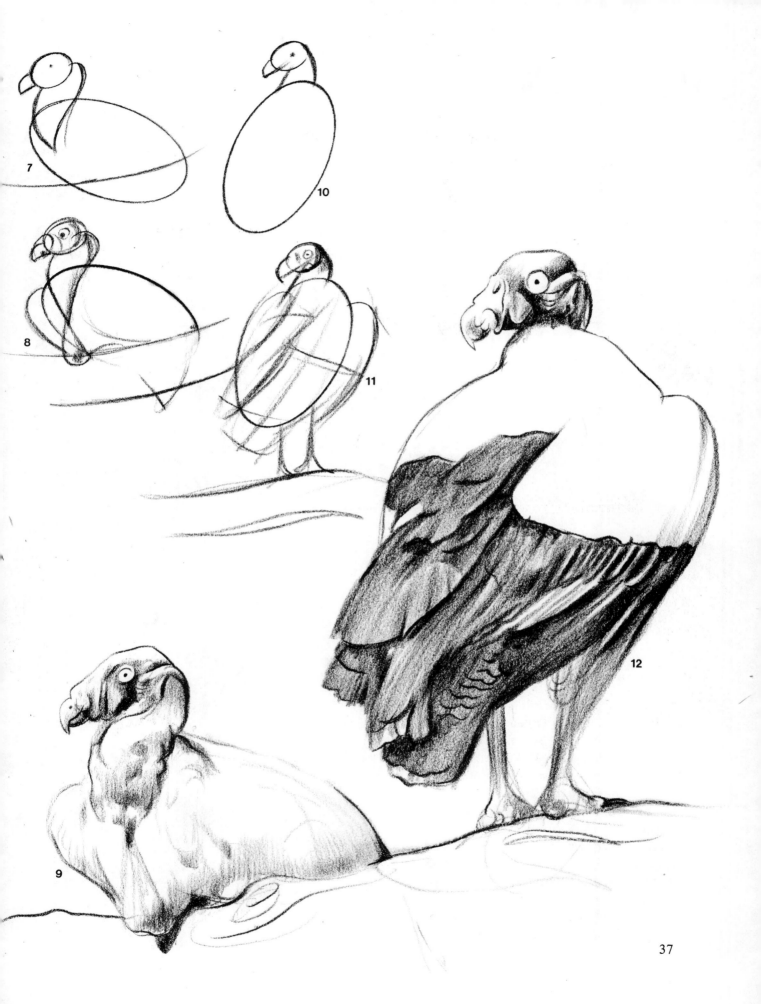

7

10

8

11

9

12

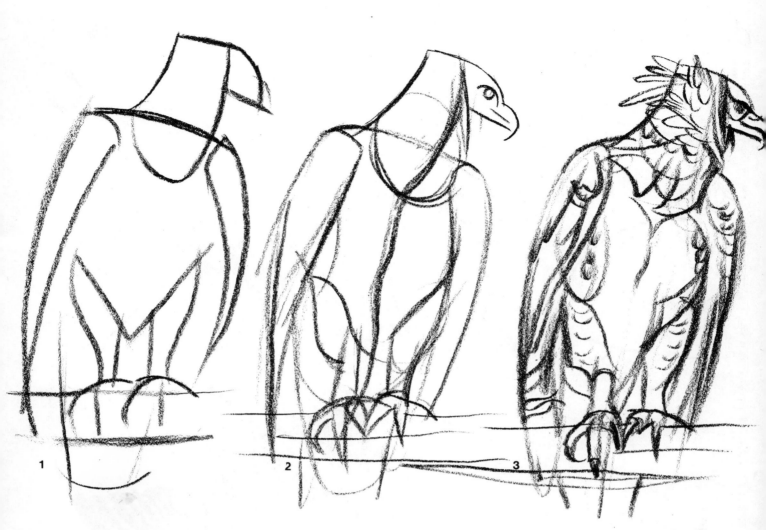

1 2 3

The harpy eagle is easily distinguished by its erectile crest feathers. In steps (1) and (2) this feature has been forgotten in favor of the basic form of the head and body. Not until (3) and (4) do the crest feathers, the harpy's enormous claws, and its other distinctive features get drawn in any detail. Concentrate on the overall pattern first and tend to the detail only in the final stages.

The face-on view (5) of the harpy seemed to miss the typical appearance of the bird. The vulture (6) points up how special characteristics of the bird, in this case the feather collar, becomes important only after the foundation drawing is well thought through.

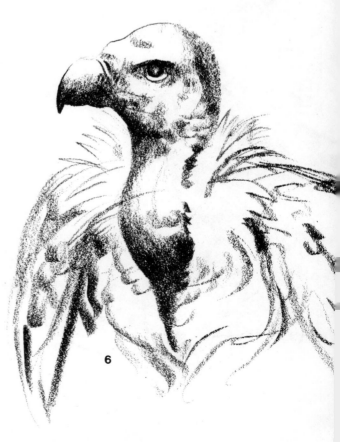

6

38

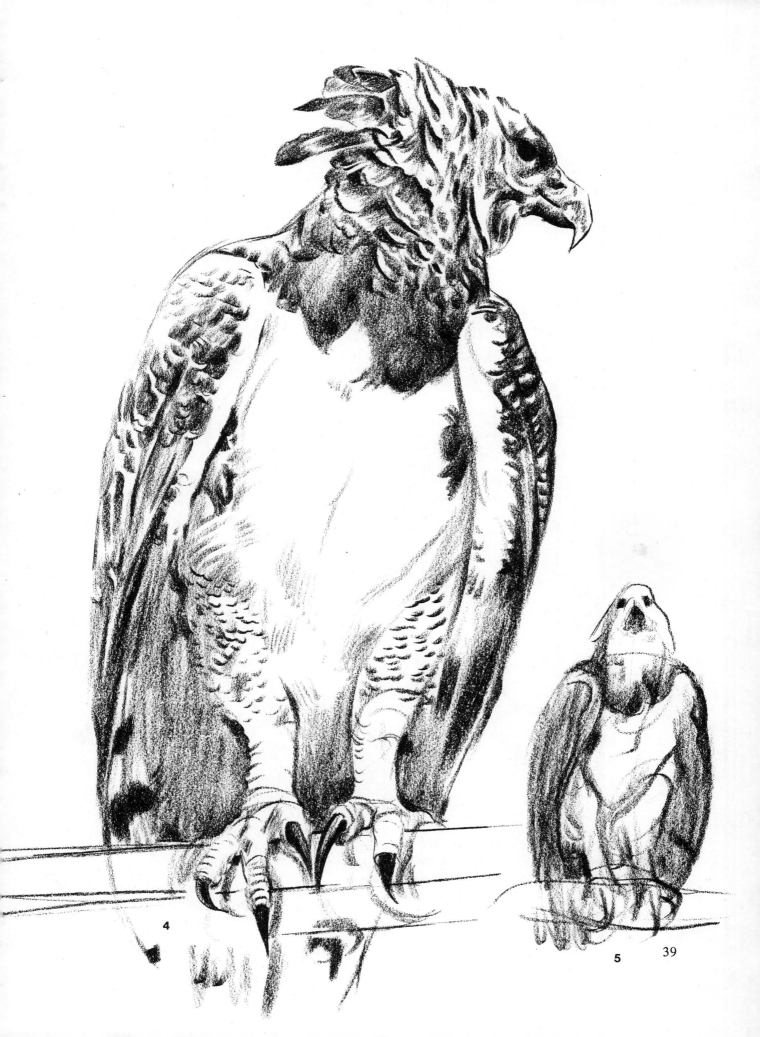

4

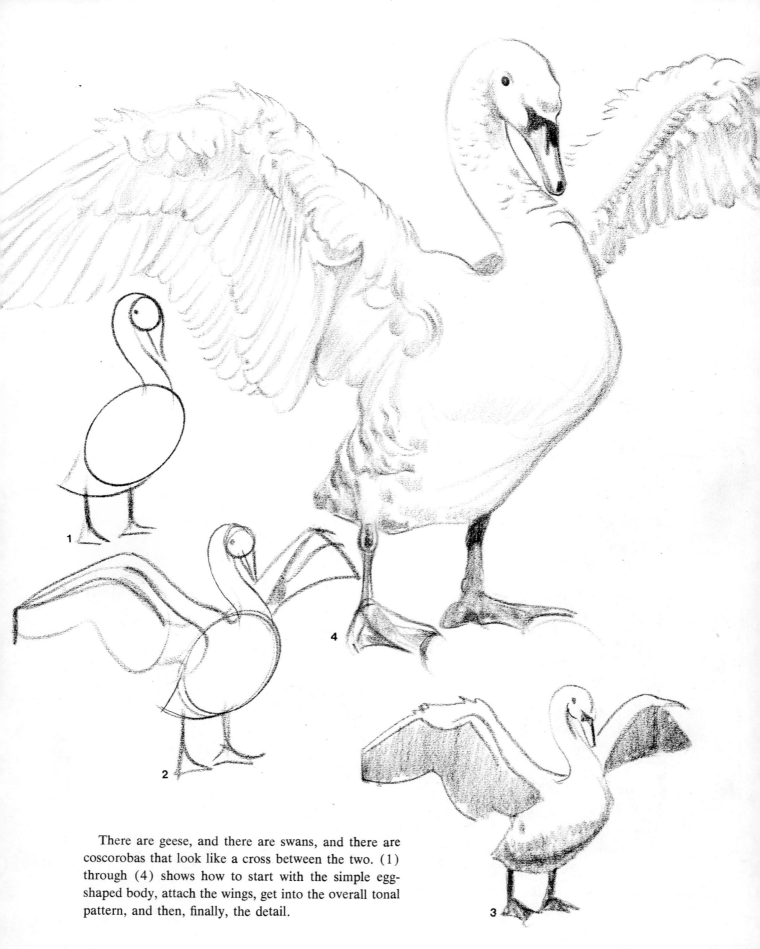

There are geese, and there are swans, and there are coscorobas that look like a cross between the two. (1) through (4) shows how to start with the simple egg-shaped body, attach the wings, get into the overall tonal pattern, and then, finally, the detail.

This page and many such pages of Canada geese preceded the working drawing of the two geese in a swamp on pages 42 and 43. The working drawing was the beginning of a painting.

The Canada goose is a favorite target of the sportsman. These birds were located at a game farm where a number had sought and obtained asylum during their annual migration.

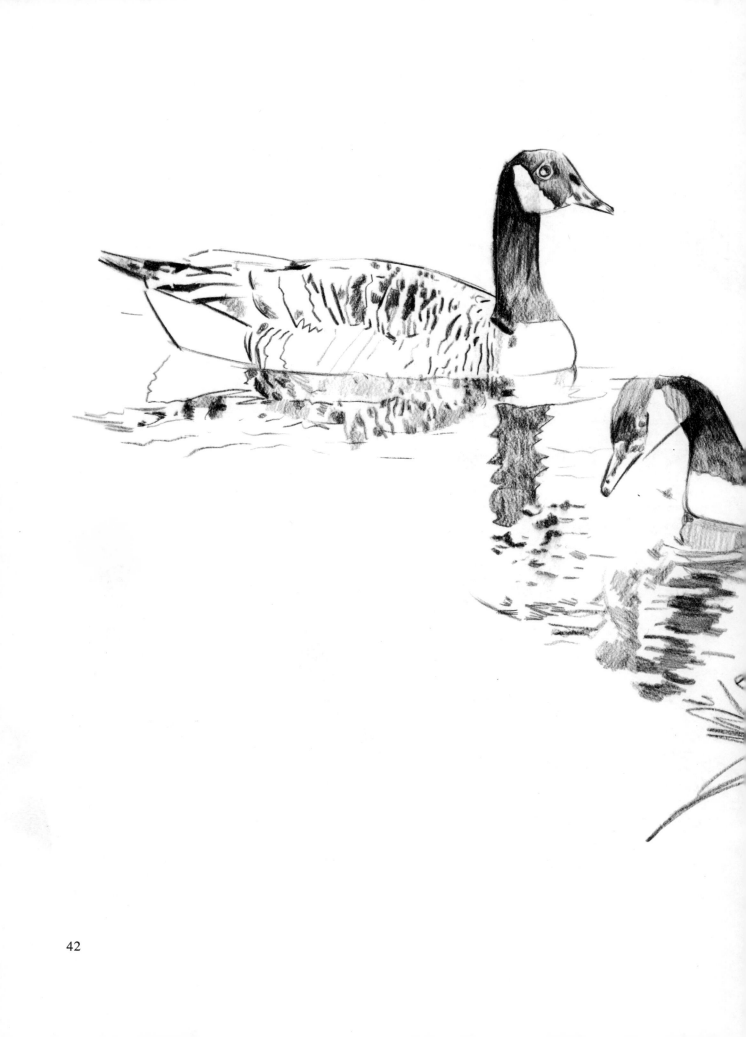

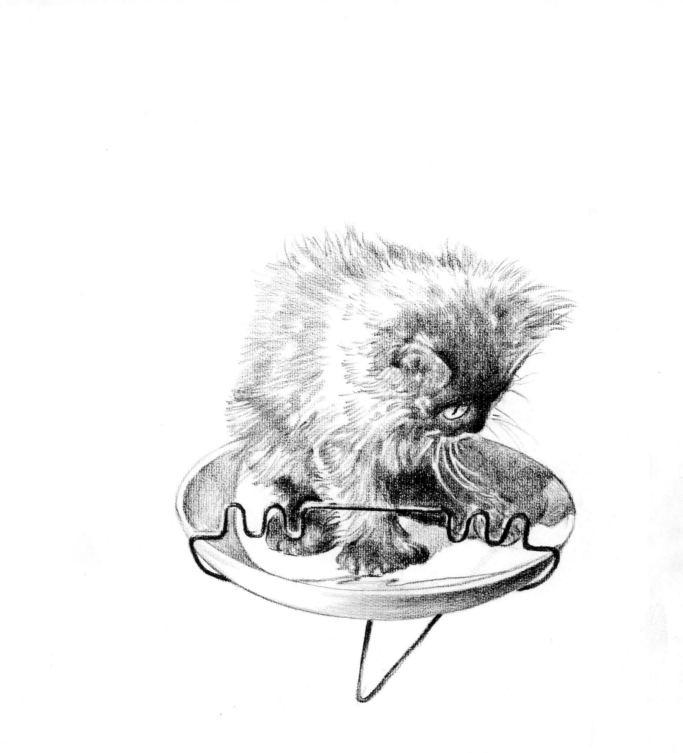

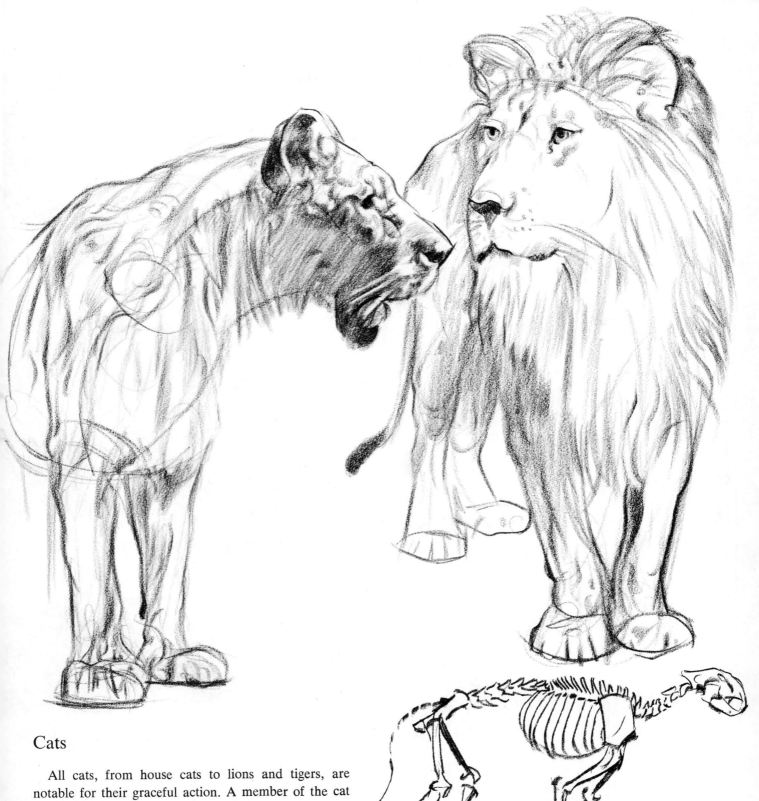

Cats

All cats, from house cats to lions and tigers, are notable for their graceful action. A member of the cat family seldom makes a jerky or awkward move. By comparison with the dog or horse, the cat's head is smaller and in most cases, more globe shaped. The rib cage is smaller, and the body longer. The average cat has a less pronounced muzzle than the average dog. Most dogs are scent hunters, while cats are sight hunters, which may account for the cat's relatively small nose.

Compare the skeleton of the lion above to the skeleton of the house cat, page 58.

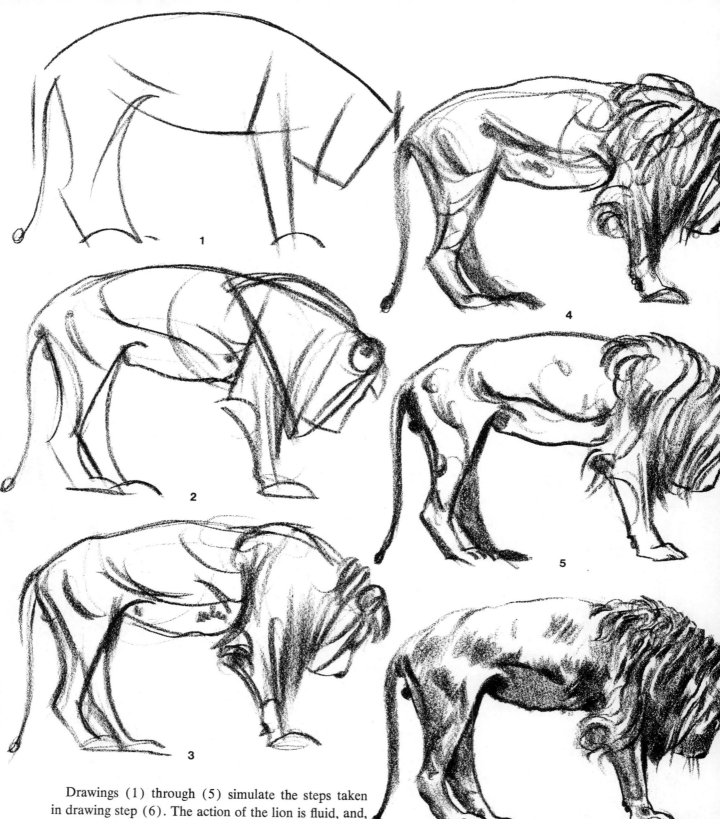

1

2

3

4

5

6

Drawings (1) through (5) simulate the steps taken in drawing step (6). The action of the lion is fluid, and, in most of the quick sketches shown, relaxed. Many of these sketches point up the fact that the long body rests on legs suspended from the shoulder in front, high on the hindquarters in back. When drawing any animal, remember to "draw through"—let the lines follow around.

Rough as the sketches are on page 47, the process used in reaching completion is the same as that shown in steps (1) through (6).

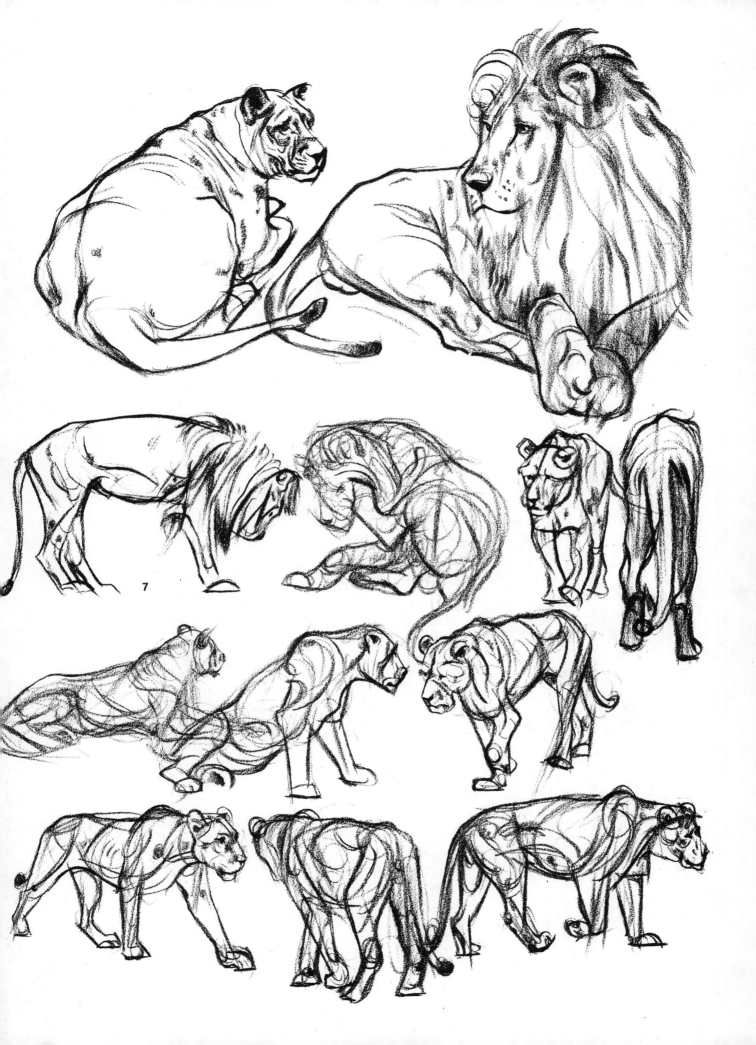

7

Drawing for zoo poster:
I Ask Him to Sound His "A",
I Get the 1812 Overture

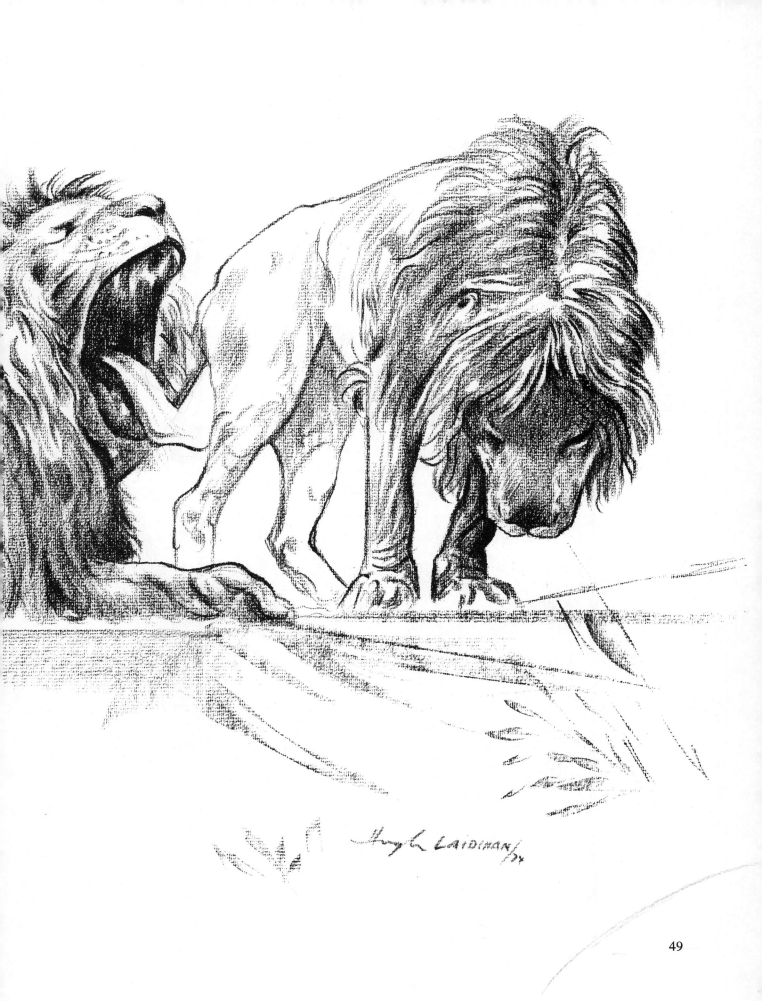

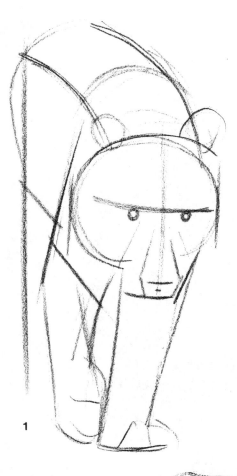

1

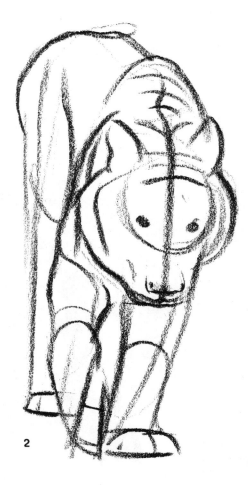

2

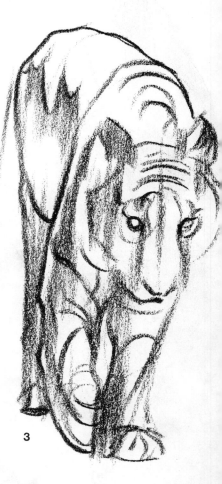

3

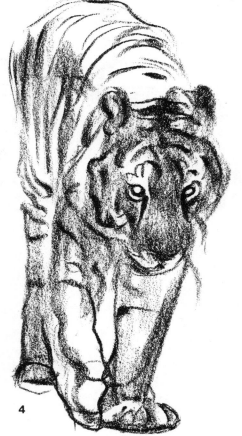

4

The tiger is the largest of the cats. A large tiger may weigh up to 650 pounds, as compared to a large lion's 500 pounds. Ten feet from nose to the tip of the tail is not unusual for the tiger. The skull differs from that of the lion in that the nasal bones extend higher on the forehead than the jawbones, instead of stopping at nearly the same line. This gives a flatter frontal angle to the tiger's head than that seen on the lion.

The tiger's stripes are not necessarily the same on both sides of the animal, and, for that matter, the markings vary considerably from one tiger to the next.

Like all cats, they are able to change from a completely relaxed attitude to a taut, every-muscle-in-action stance in a split second.

In (1) the approach to the sketch is blocklike. The action, the proportion, the personality of the cat, are the targets. (2) and (3) are refinements and corrections of the first lines. It is not until (4) that the tiger's stripes become important. When the stripes do come into the picture, they are used to help show the tiger's conformation.

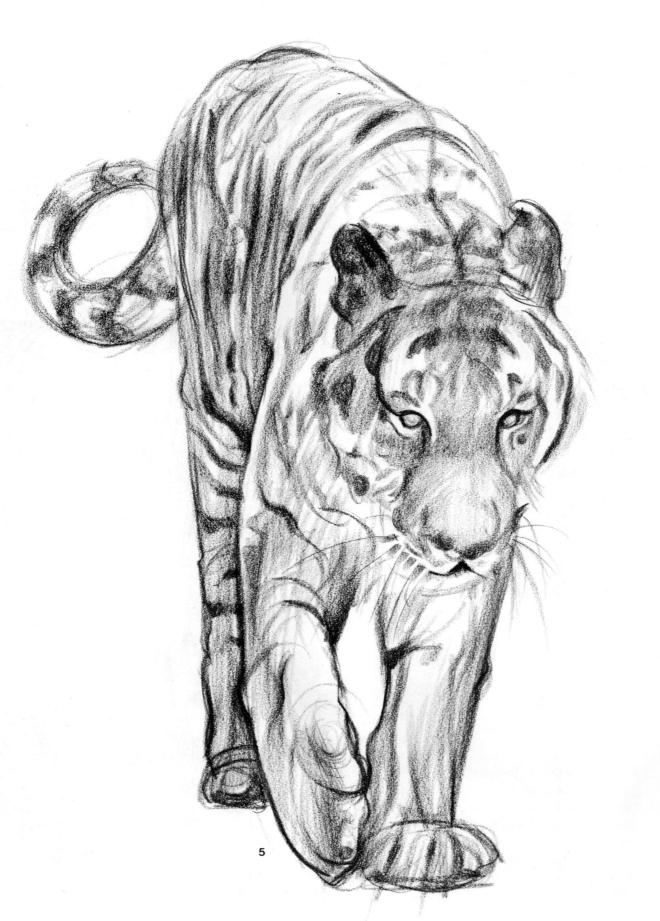

5

Preliminary steps (1) and (2), leading to the finished sketch (3), illustrate two possible beginnings for drawing a tiger. In (1) the blocking is done with rather rigid lines, while in (2) an oval was used. Steps (4) and (5) lead to the finished sketch (6). (4) demonstrates the simple rhythmic line. (5) uses the "block" approach. (7) begins with a quick impression of the action, while (8) is "doodled." Either one could lead to the more realistic sketch (9).

52

1

2

3

4

5

6

7

The cheetah, shown in progressive steps (1), (2), and (3), can reach a weight of 140 pounds and attain speeds in excess of 70 mph. He is tall, between 30 and 36 inches, and has a relatively small head and slender body. The claws are semi-retractile. The cheetah differs from the leopard in appearance. Its markings are oval rather in a rosette pattern.

In (1) the preliminary pattern generally is a triangle. The aim of step (2) is to develop the flowing lines of the cheetah. In (3) detail is added to finish the sketch without losing the action of (2).

Another long-legged cat, with a small head and large ears, is the serval cat. His dark spots are on a tawny background. On the back these spots become elongated. The serval is about 20 inches tall. It feeds chiefly on small mammals, but is not above an insect snack now and then, especially beetles. Somehow, the serval combines the impression of a gangly teenager with that of a ballet dancer, as shown in (4), (5), (6), and (7).

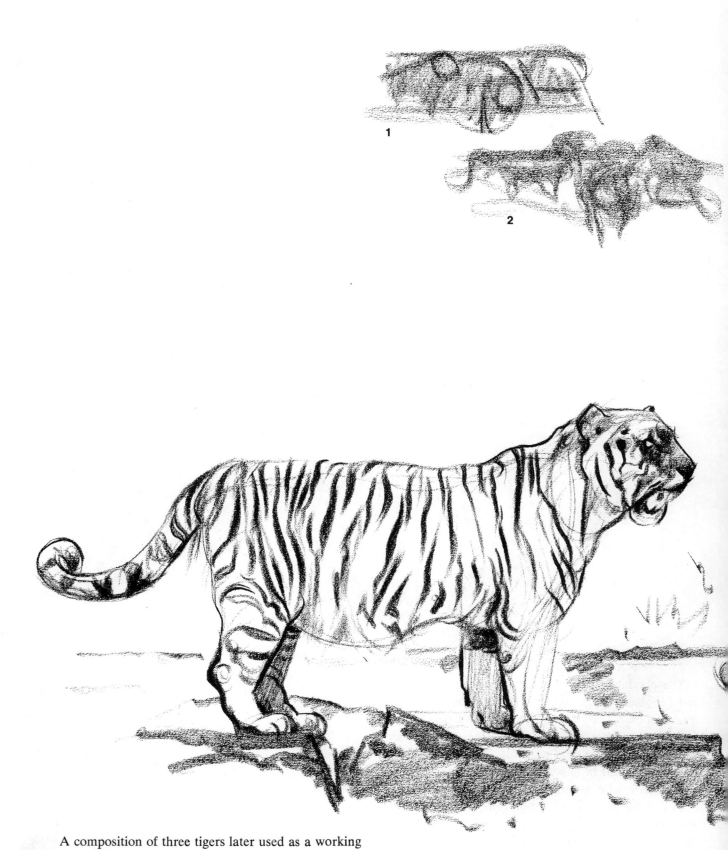

A composition of three tigers later used as a working drawing for a painting.

The sketches (1) through (4) are preliminary thumbnails done for composition.

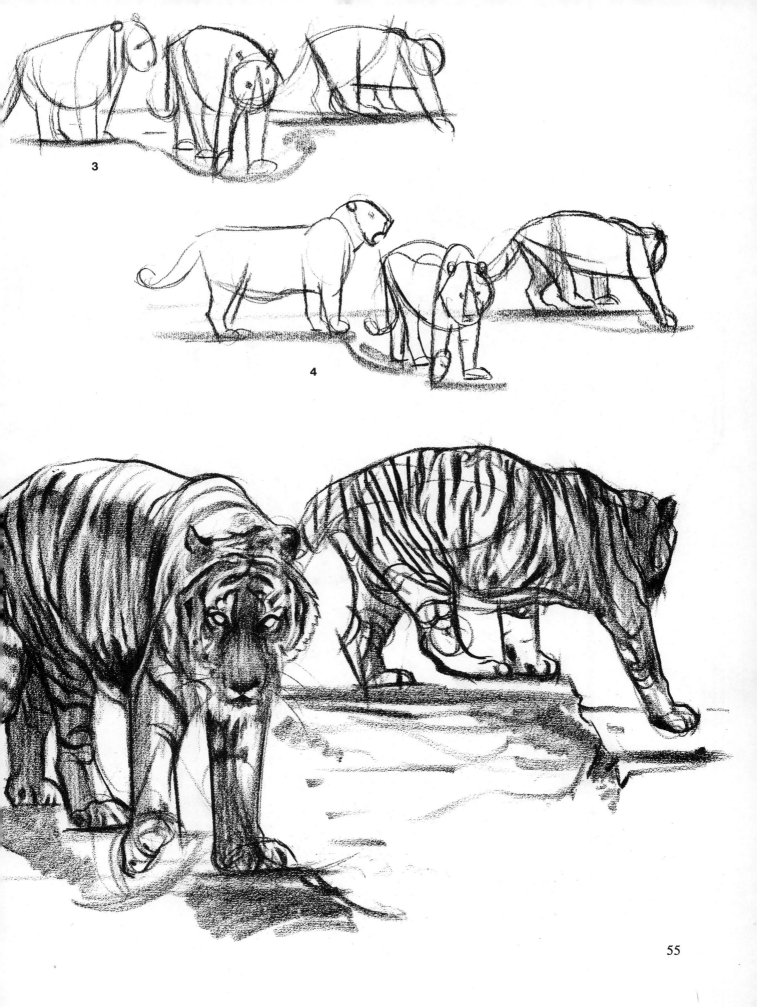

3

4

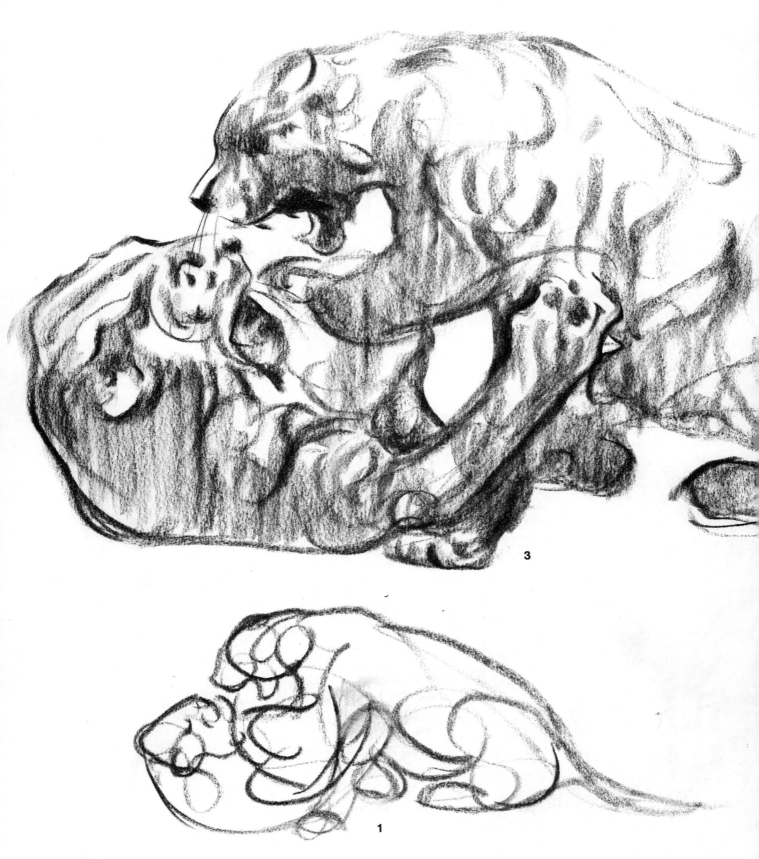

The two combative black panthers were drawn in very large scale using a stick of vine charcoal. (1) through (3) show the method.

56

2

57

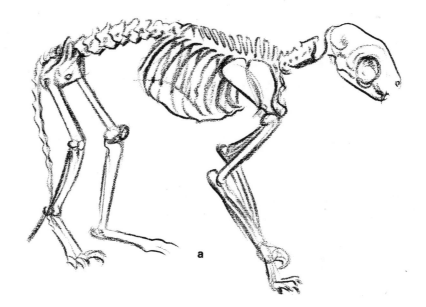

The skeleton (a) is that of a house cat; (b) is a simplification of (a). Cats have relatively small heads. In silhouette, they do not show much of a "tuck-up." The expression "tuck-up" is generally used to describe the silhouette of an animal's underbody. A dog with a large chest sweeping back to a small waist, such as a borzoi, might be said to have a pronounced "tuck up" as compared to the almost straight line from chest to rear section in most cats.

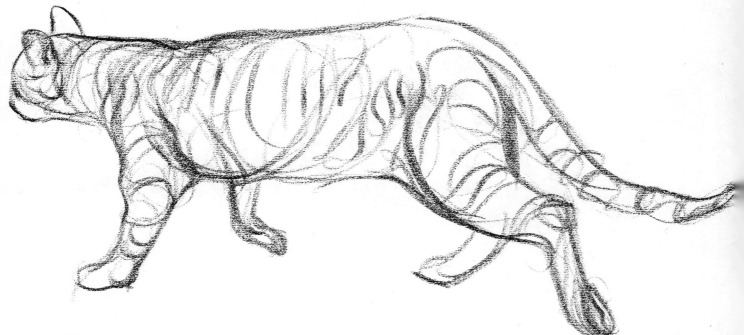

In drawing cats, be they highbred or low, it is a good idea to compliment the owner on his pet. Most avid cat fanciers are, in themselves, a breed apart. This is most evident at a cat show where the owners, sitting and currying their pets, are completely oblivious of anyone unless that person happens to be a TV cameraman on assignment. Cat owners of one breed generally see nothing outstanding in another breed.

The general shape of the cat's head fits nicely into a circle (a). The sitting cat (b) displays a curved back line.

Draw an accurate line interpretation of a cat (1). Using this drawing as a guide, indicate only the surface design of the cat's coat (2).

Attempt to capture the feeling of the cat (3) in a minimum number of strokes. Indicate the basic shadow pattern (4). Concentrate on characteristic details of eye, mouth, nose, and whiskers (5).

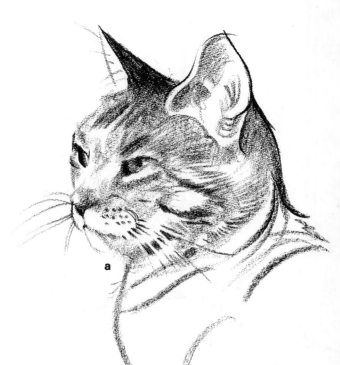

a

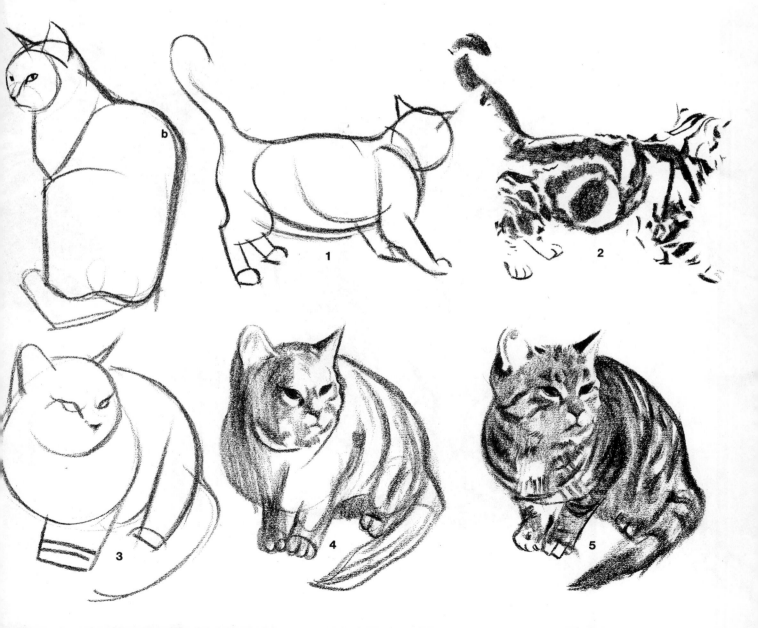

b

1

2

3

4

5

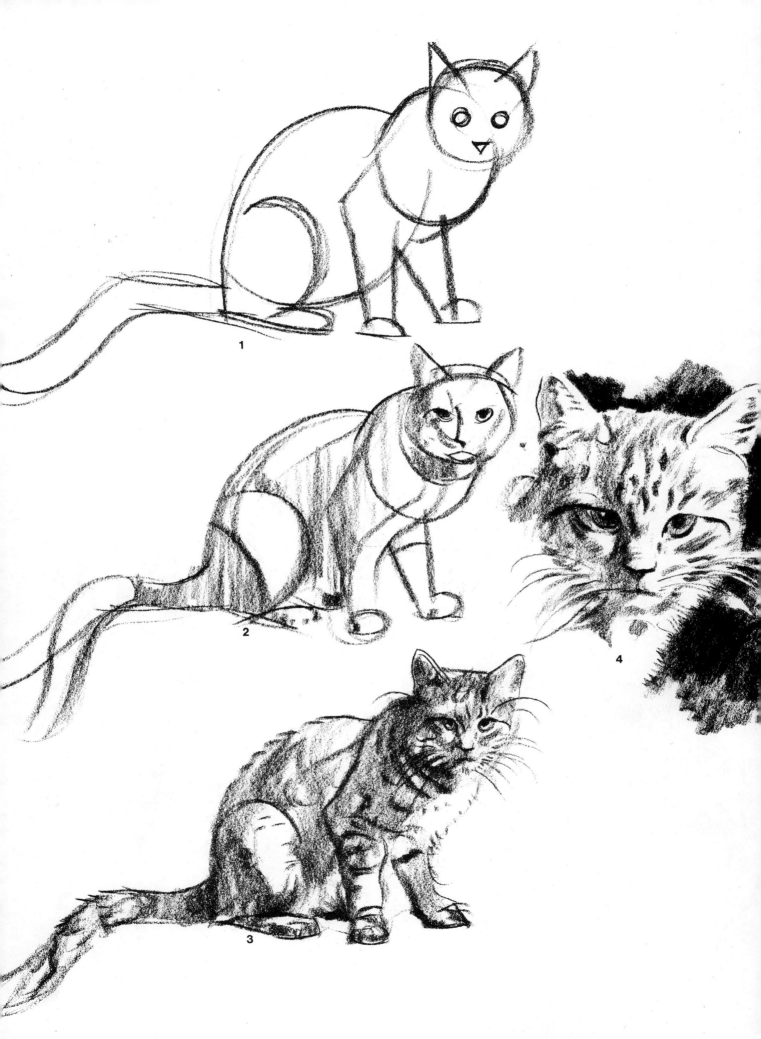

1

2

3

4

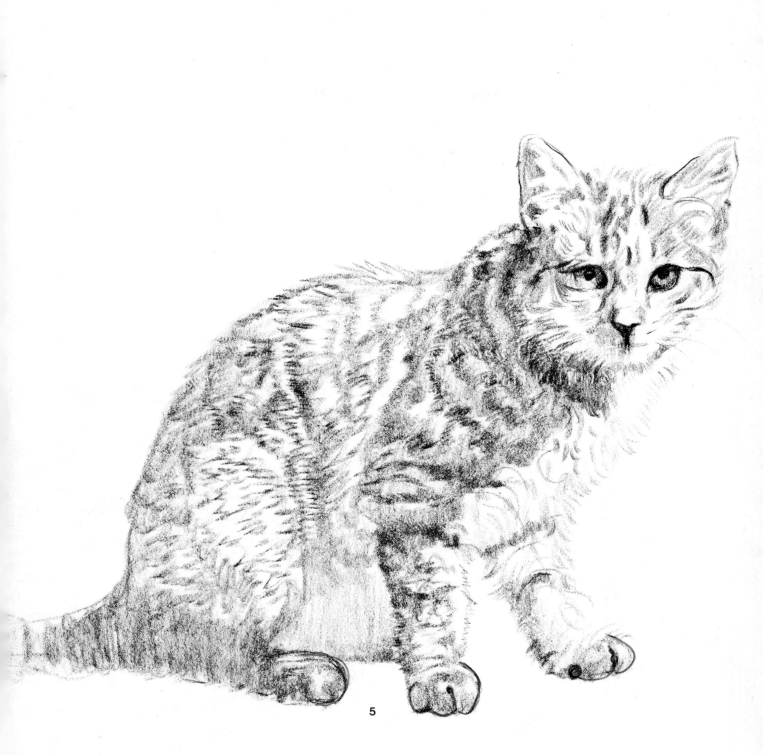

5

This is a "barn" cat, unidentifiable from an "alley" cat except that it appears better fed. Sketch (1) is the cat drawn with a minimum number of lines. Sketch (2) begins the first indication of light and shade. In (3) the scruffy appearance is featured. The study of the head (4) completes the preparatory work for the sketch (5).

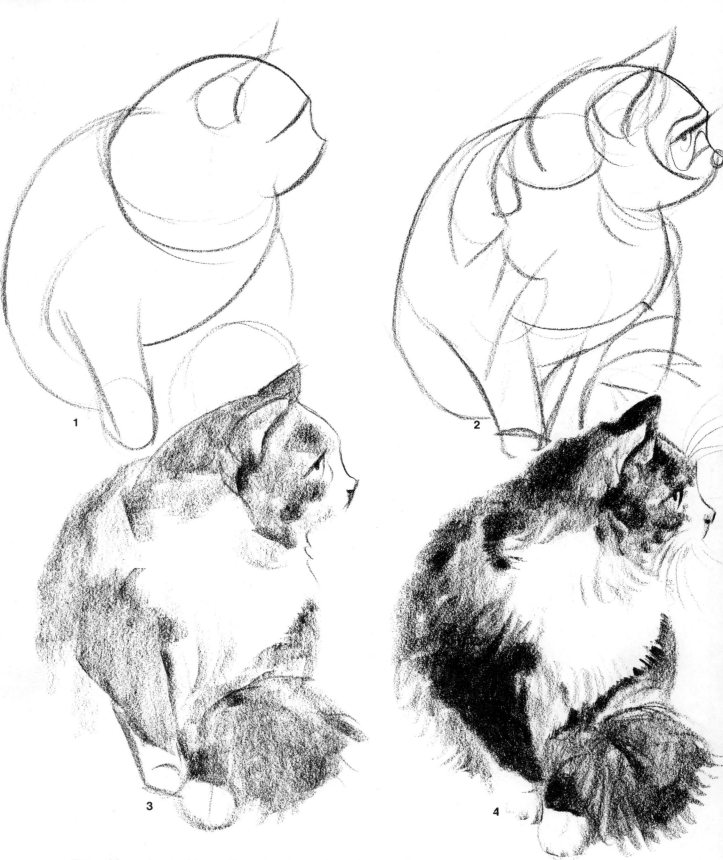

Everything about this pedigreed cat speaks of a
different background from that of the "barn" cat—not
only the beautifully groomed, long fur, but the way it
poses. The long fur can be trouble for the artist because
it hides the underlying structure. As you draw steps (1)
through (4), attempt to eliminate all but the most telling
passages.

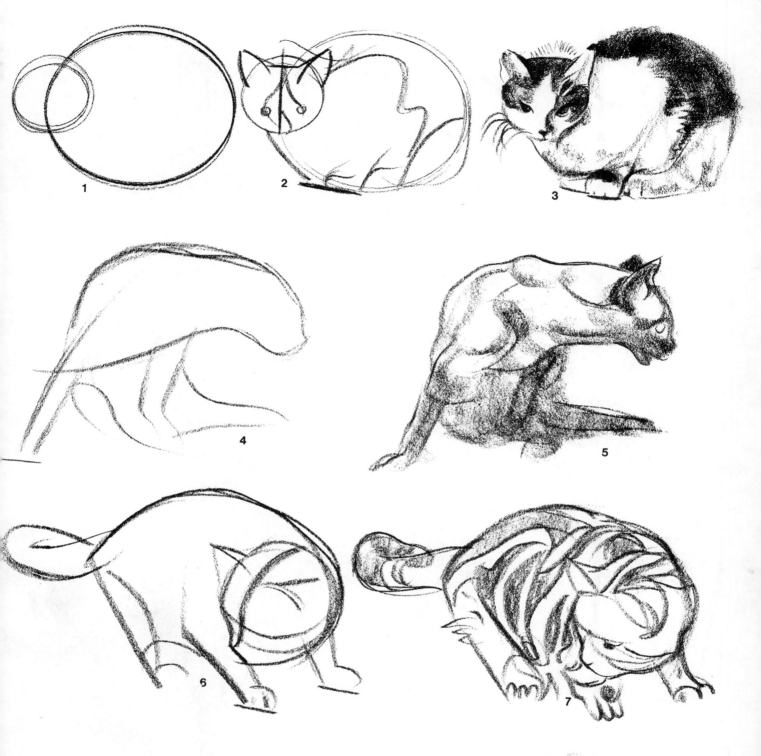

Cats of indiscriminate lineage, like the cat shown in steps (1) through (3), generally have a resigned appearance. The Siamese, in (4) and (5), has an action that seems to suggest the snake. The highly bred and strongly marked tabby in (6), (7), and (8) gives the feeling of a coiled spring.

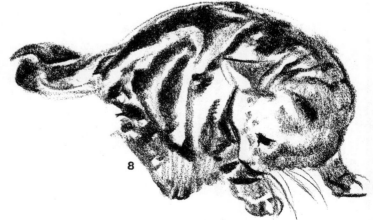

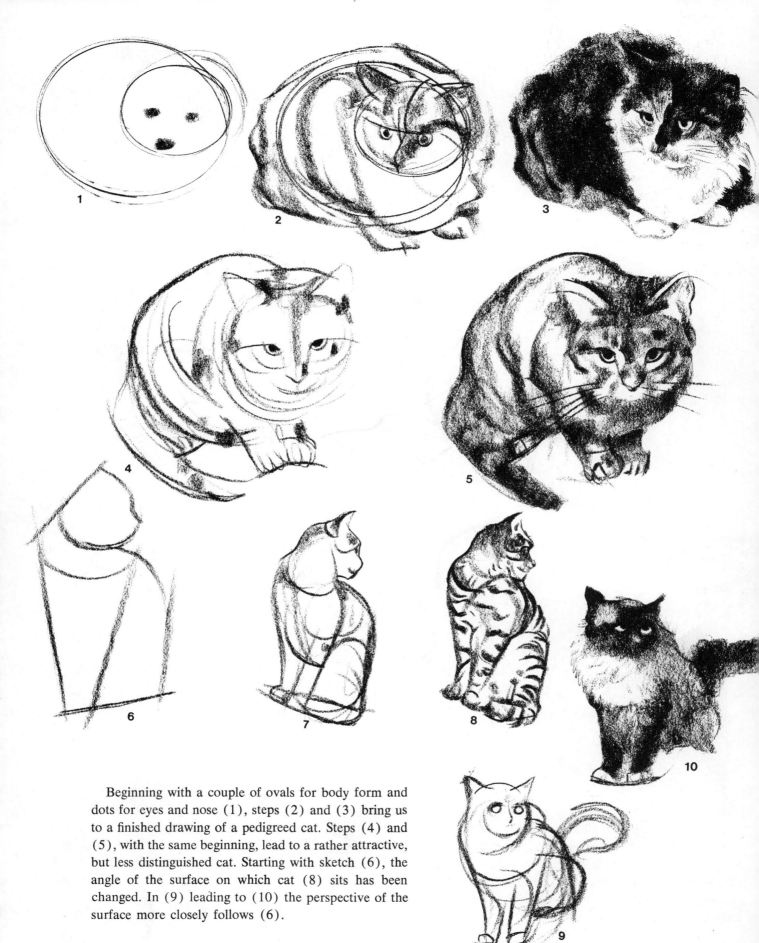

Beginning with a couple of ovals for body form and dots for eyes and nose (1), steps (2) and (3) bring us to a finished drawing of a pedigreed cat. Steps (4) and (5), with the same beginning, lead to a rather attractive, but less distinguished cat. Starting with sketch (6), the angle of the surface on which cat (8) sits has been changed. In (9) leading to (10) the perspective of the surface more closely follows (6).

64

1

2

3

4

5

6

The long fur on the Persian is not the only distinctive feature of the breed. The face has a pug-like appearance. This single feature is analyzed in steps (1) through (6).

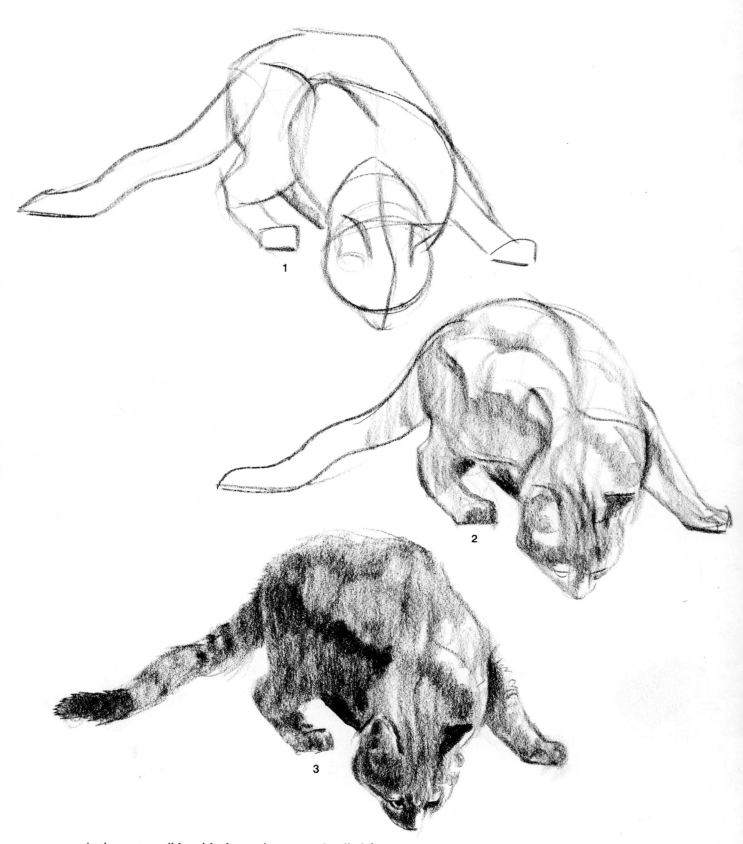

Action compatible with the setting seemed called for in drawing *The Cat in the Colosseum*. Although the cat is motionless, a feeling of action was necessary. This action was caught in sketches (1) through (3). In (4) the background was roughed in along with detail on the animal to emphasize the devil-may-care appearance of the Colosseum cat.

66

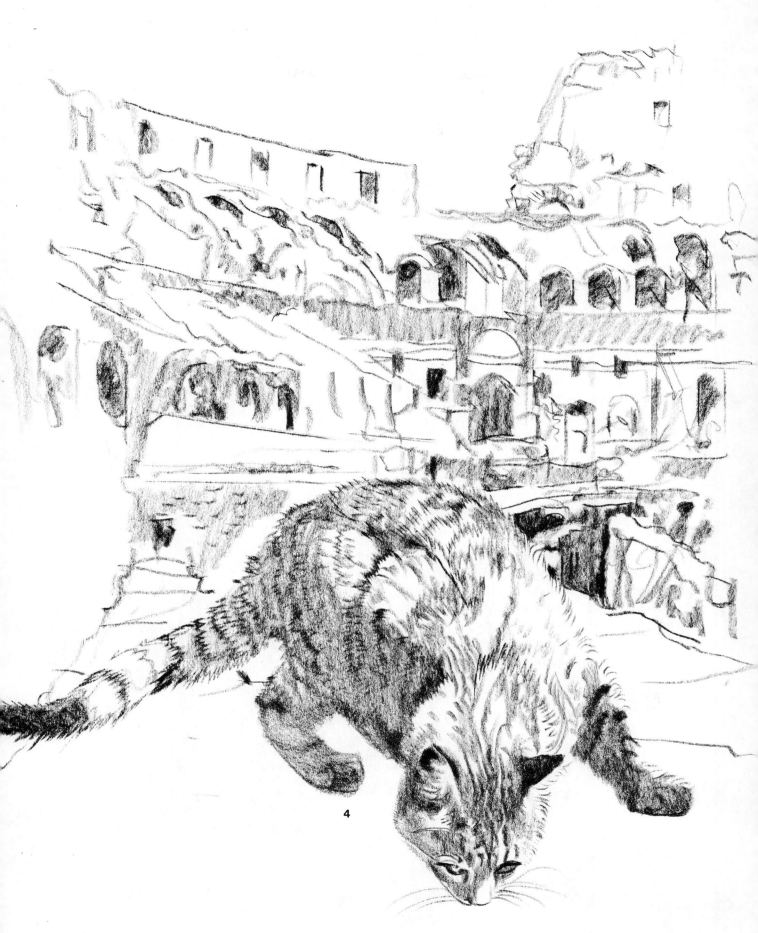

4

The preliminary sketching that precedes sketch (5) of the reclining cat illustrates the thinking of the artist. In (1) simple ovals place the sketch on the page. (2) indicates the general position of the legs and ears. In (3) the form of the cat is blocked in. (4) is the first indication of the texture of the long fur. The texture of the cat's fur was finally drawn in (5) with the side of the pencil.

Canines

Although canines differ greatly in appearance, their basic structure is the same. Within the category of dogs alone, full-grown animals can range from the Chihuahua, who can nest comfortably in a man's hat, to the Irish wolfhound, capable of carrying a child.

The fur coat of the German shepherd reveals the contour of the solid form beneath. The rough coat on the wolfhound is short enough to indicate the hound's structure. The Great Dane, with his short, shiny coat, lets the artist see muscles in action. The form is less apparent in long-haired dogs, but the artist must be constantly aware of the underlying structure. He must not just draw hair.

Dogs also vary greatly in temperament. In drawing a specific breed, the artist must think of the nature of the dog. In drawing a terrier, he attempts to capture the feeling of exploding energy. The wolfhound was originally bred to run down his quarry and make his own kill. He has a powerful, fluid action. Even in repose, there is a feeling of grace and strength.

All small dogs are not highly strung terriers. The Lhasa Apso is no terrier. He is considerably less high-strung, and although capable of action, his is not a nervous action.

Know something about the dog before you draw. With knowledge of the breed, you can bring out its special characteristics.

Compare the dog skeleton (a) with the skeleton of the bear (b). Note the proportion of rib cage to overall frame and the relative curve of the vertebrae. They are both canines, but close similarities stop here.

The dog walks with his heel raised from the ground. The bear walks with his heel on the ground. Both bear and dog have their legs hinged high on the body. This is true of most animals.

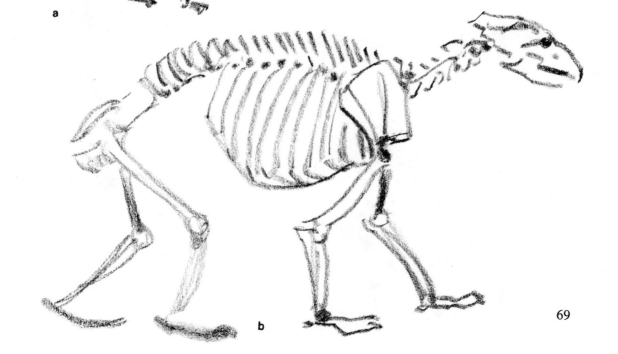

a

b

69

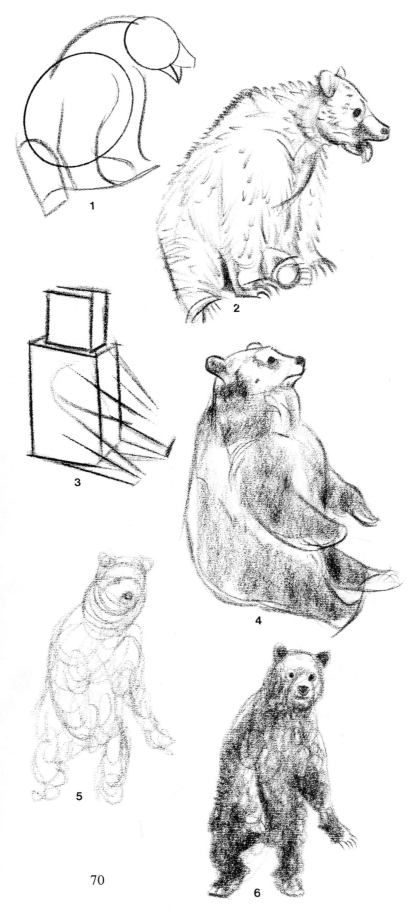

A large ellipse for the basic body shape and a small ellipse for the head are the beginning of the drawing of the bear (1). With a swinging gesture line, the head and body are connected and the legs indicated. Over this diagrammatic sketch, the fur, eyes, paws, and other details are drawn (2).

The stance of the second bear (3) seems to suggest a more rectangular approach—a small block for the head, a larger one for the body, with the limbs indicated in simple form. How this stage is executed will determine whether or not the next stage (4) will convince the viewer that the bear is sitting.

(5) is the doodling approach, with pencil constantly in motion, seldom leaving the page until in (6) the finish is a mass of doodled fur.

In (7), after going through any of the basic approaches, emphasis is on the details of claws, paws, eyes, and muzzle.

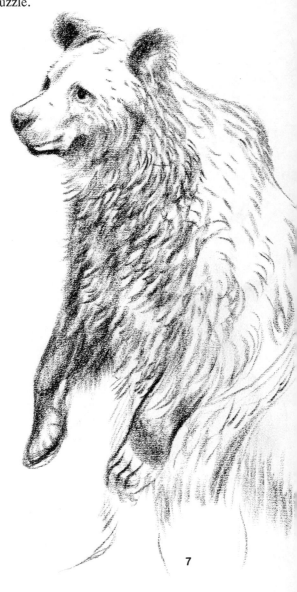

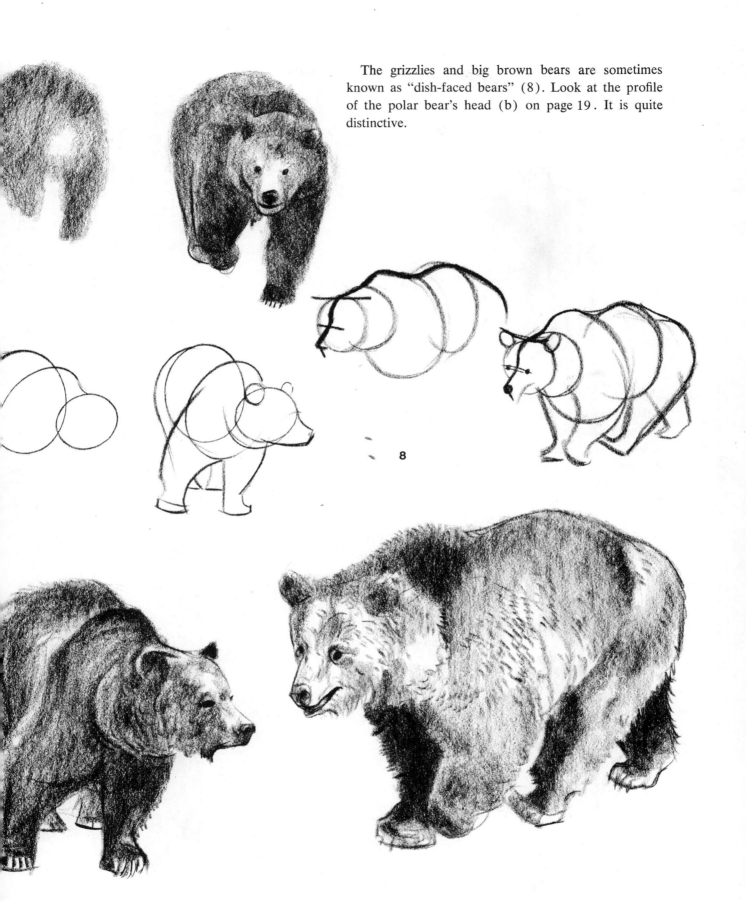

The grizzlies and big brown bears are sometimes known as "dish-faced bears" (8). Look at the profile of the polar bear's head (b) on page 19. It is quite distinctive.

8

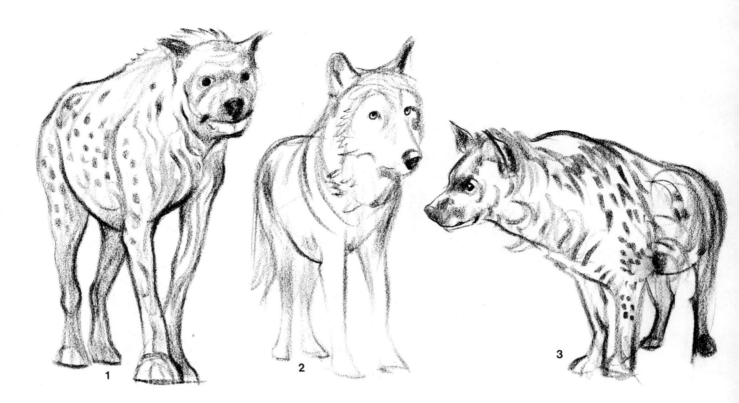

1

2

3

Wolves closely resemble dogs, but there is a marked difference between the dog and the spotted hyena (1). The spotted hyena weighs from 120 to 155 pounds, is some 30 inches tall, and can run 30 mph. Although a nocturnal animal, I saw this one in daytime walking far behind a haphazard parade of lions. The lionesses and cubs were intent on a prospective kill. The hyena was drooling over the prospect of leftovers. The hyenas (3) and (4) were in the Bronx Zoo and were considerably less menacing. (5) through (7) illustrate the hyena's powerful jaws and heavy shoulder section. Unlike the wolf (2), it has a bristly mane and short hind legs. The hyena's short hind legs tend to give it an awkward looking walk. Its reputation for cowardliness and its unearthly cry are facets that the artist should bear in mind when drawing the animal.

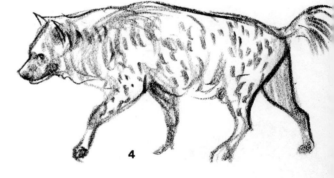

4

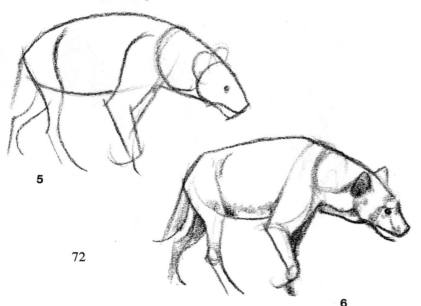

5

6

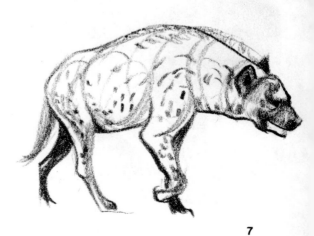

7

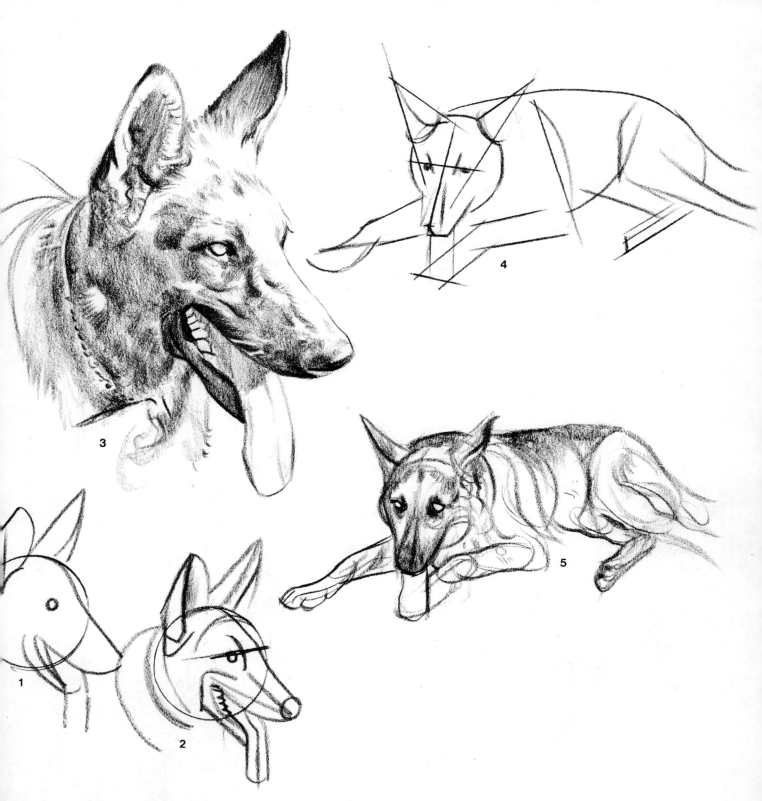

At first glance, the German shepherd looks like a well-groomed wolf. The differences are caused by life style and function.

Beginning with a circle, the eye, muzzle, and lower jaw are indicated (1). The first rough lines that will become the ears are drawn, with their function in mind. They are quite efficient ear horns, able to face and catch sounds from any direction, much like the fox and the jackal.

In (2) the lines of (1) are augmented and enforced. In (3) the details of light and shade complete the head. (4) is a beginning, using a combination of almost ruler-like lines and curves that lead to (5), where we have employed a bit of tone, along with more fluid lines.

73

The Irish wolfhound (1), (2), and (3) and the Great Dane (4) and (5) are two of the largest domestic breeds. These progressive steps were drawn in attitudes typical of each.

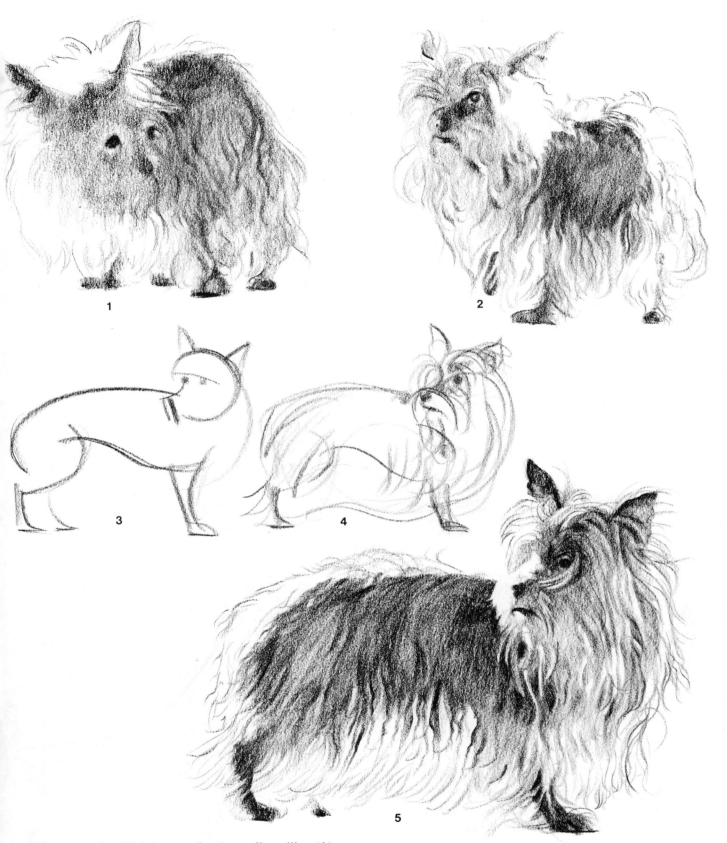

The strong backlighting on the Australian silky (1) and (2) points up the conformation of the animal hidden under the long fur. (3), (4), and (5) demonstrate how the artist must constantly keep underlying form in mind. Unless this form is correct, the little dog will not look like he belongs to the dog family, something he has difficulty doing even on an average day.

The stance and attitude of the poodle would make him recognizable without any of his varied hairdos. Whereas an old hound dog might appear overly relaxed, the poodle seems, at all times, like a tightly wound spring.

Step (1) catches the form of the dog in the simplest of lines. (2) is the light-and-shade pattern, while (3) employs a doodling technique to indicate the typical poodle coat. (4) begins the portrait with a circle. In (5) we finish with the light-and-shade pattern over the basic form. Catch the action of the animal in as few lines as possible (6). Execute the final drawing in as few tones as you can (7).

The Lhasa Apso's underlying form is even more hidden than the Australian silky's, for it seems to follow no plan whatsoever. In (1) start with the simple form leading to lines that indicate fur in keeping with the breed. Not until the sketch is well under way (2) do you strengthen the eyes, the muzzle, and other details. (3), (4), (5), and (6) are positions typical of a puppy of the breed.

1

3

2

4

Before sketching a golden retriever you might take a series of shots with a fast camera. Otherwise, a dog constantly in violent action can be drawn only with intense concentration. The approach is shown in (1) through (4).

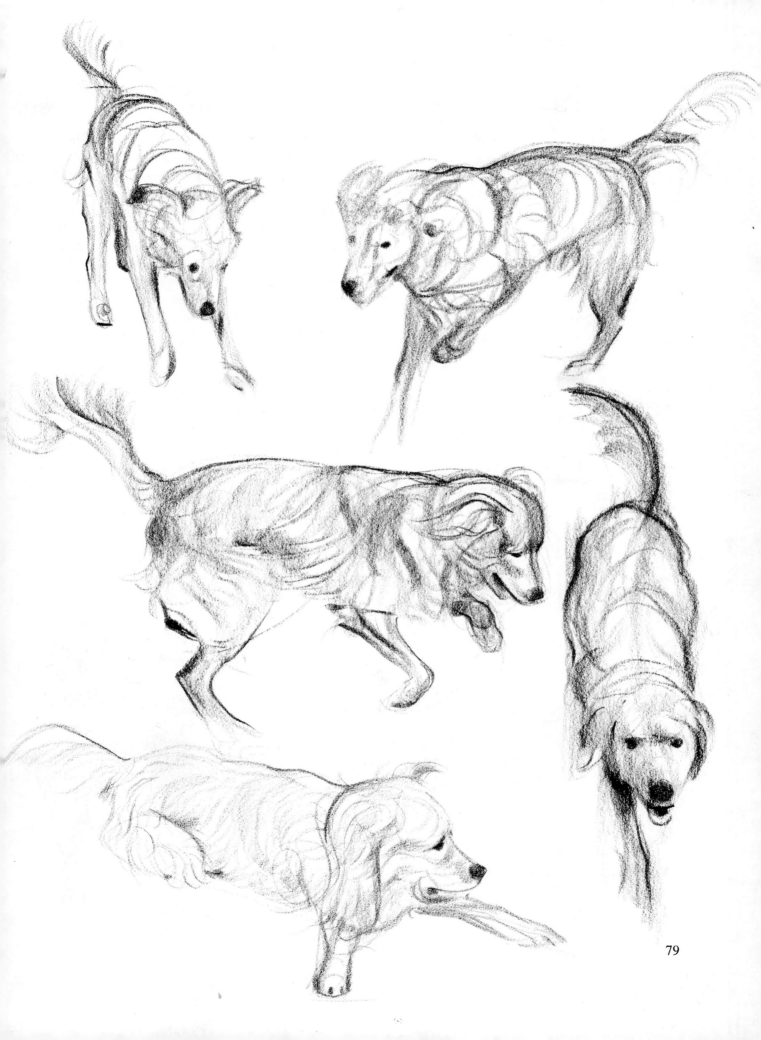

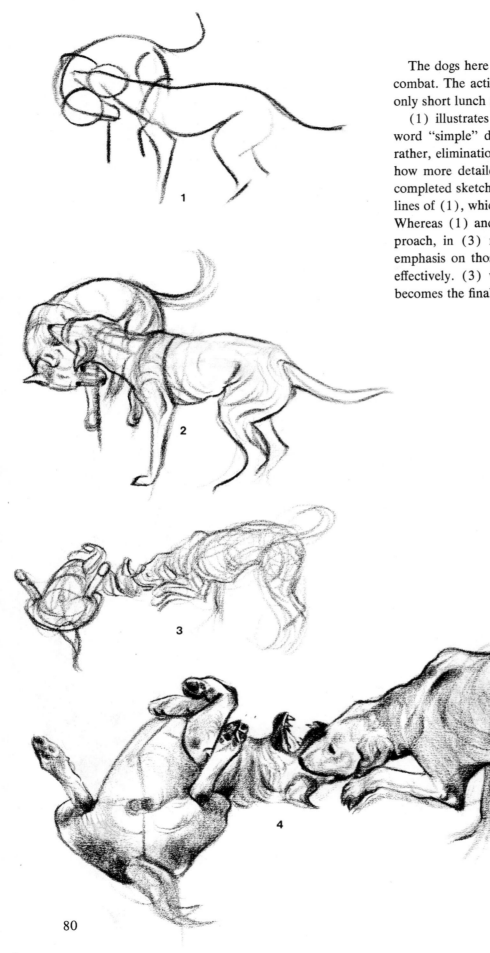

The dogs here were playing or in some stage of mild combat. The action continued all through the day with only short lunch and supper breaks.

(1) illustrates the simple action line approach. The word "simple" does not imply ease of execution, but rather, elimination of all unnecessary detail. (2) shows how more detailed and involved lines are used in the completed sketch. These, of course, are drawn over the lines of (1), which could be a finished drawing in itself. Whereas (1) and (2) use a definite and deliberate approach, in (3) many lines are drawn, with the final emphasis on those that seem to catch the action most effectively. (3) with more and more definition added becomes the final drawing (4).

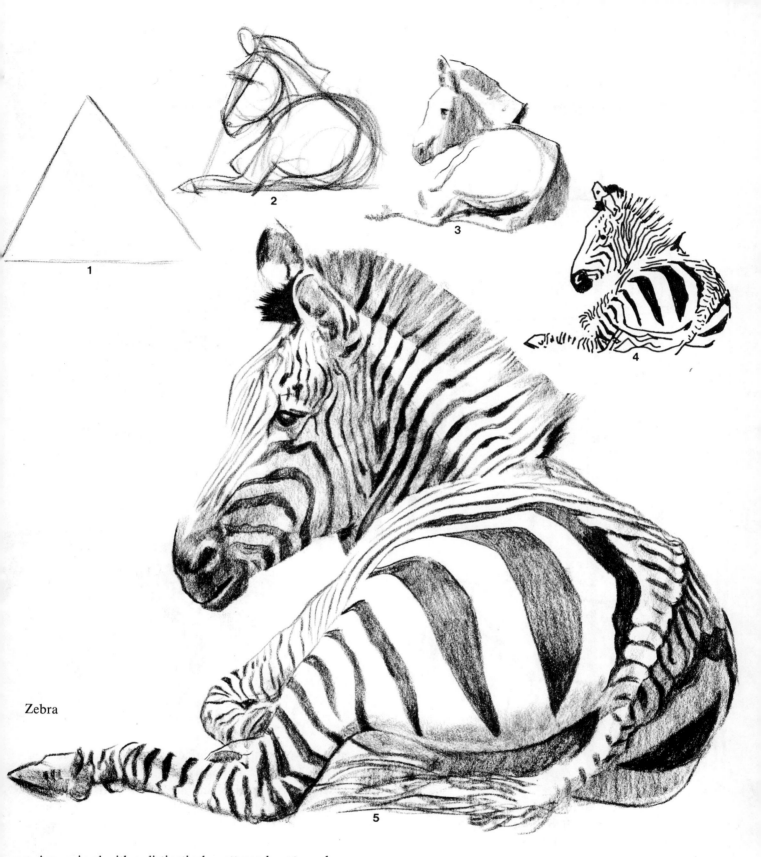

Zebra

Any animal with a distinctively patterned coat can be indicated by drawing only the pattern. The zebra, a member of the horse family, is an example (4). The final drawing (5) includes light and shade.

In any case, the artist must first carefully establish the animal's form, working from a simple (1) to a detailed (3) conception.

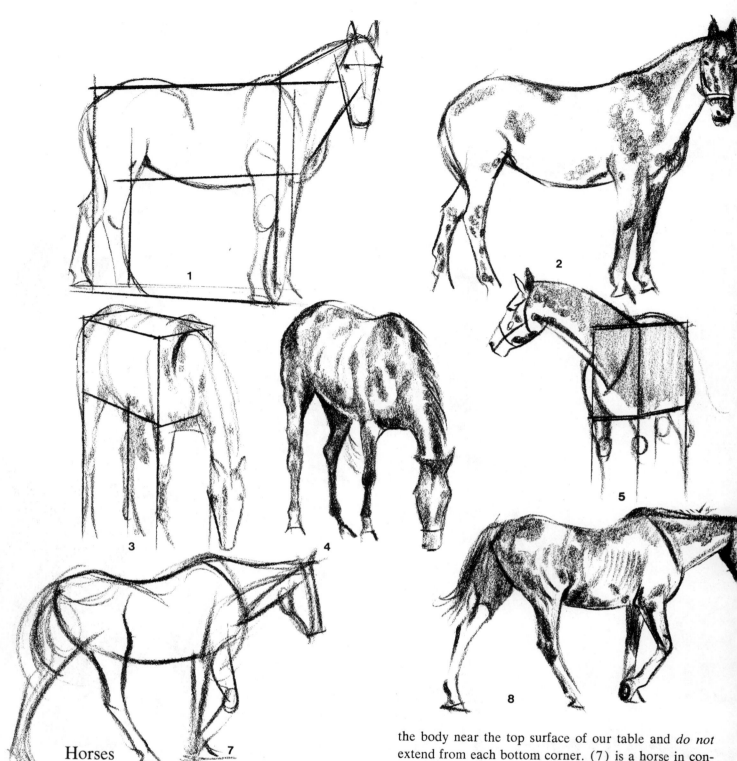

Horses

The general form of any of the many breeds of horses can be made to fit into a rectangle (1). (2) is the continuation into a more finished sketch. (3) carries the box shape further, while (4) is the sketch completed. (5) illustrates how the underlying construction of a standing horse could be likened to a heavy table with thin legs. The legs, however, in all the animals, are connected to the body near the top surface of our table and *do not* extend from each bottom corner. (7) is a horse in considerably more action, and might well start with simple action lines leading to (8), the more complete sketch. In drawing (8) it helps to know about the underlying bone structure, shown on page 106.

If the final drawing is to be ink, felt pen, brush and ink, or water color, the initial stages of the drawing—the construction, mistakes, and corrections—can be erased. In a charcoal drawing such as this, it is best

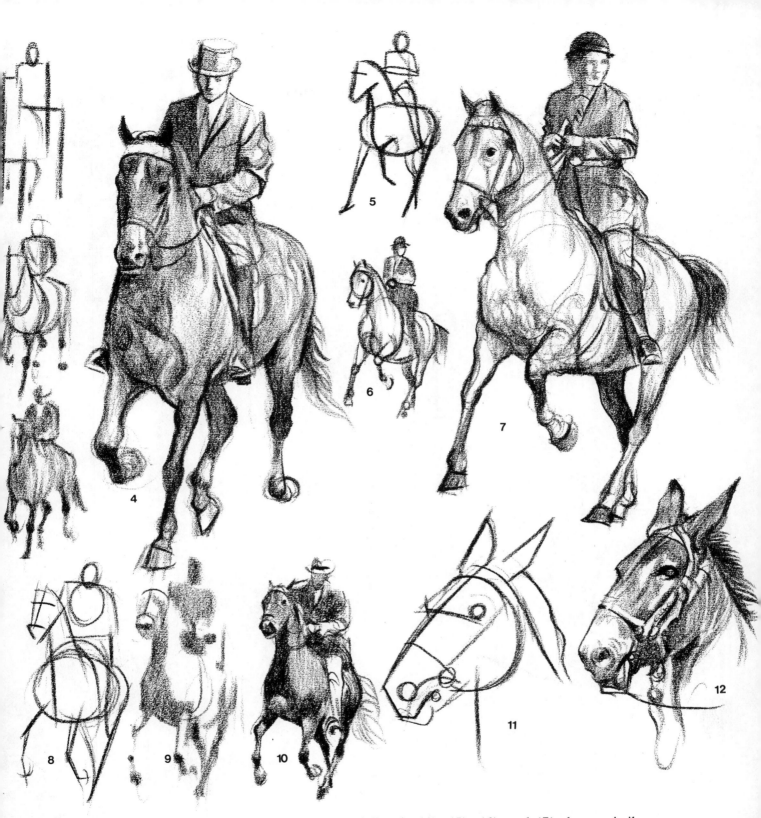

either to sketch the original steps lightly so that they will disappear in the finishing process or to trace the corrected sketch onto a fresh sheet of paper.

(1) is a simple cubist impression of the subject. In (2) the sketch is carried into curved shapes. In (3) we bring in an over-all tone pattern. The details and accents follow in (4). (5), (6), and (7) show a similar progression. In (8) the first action lines show the rider on a seemingly transparent horse. (9) illustrates the shadow pattern and (10) the details. (11) and (12) show a mule's head. Note how it differs from the horse's head in (7).

83

The trooper and horse was first roughly blocked in minus the trooper (1). In (2) further sketching includes not only the trooper but also the beginnings of the gear and other details. At this stage, the troopers entire body could be roughly indicated, although the parts hidden by the horse will not be in evidence in the final sketch (3).

In sketches (4) through (6) the lines of the horse have been drawn through the rider. (7) and (8) are examples of drawing the horse from many angles. When sketching, whether from photographs or life, think of the front, sides and back of your subject, not just the view of the animal you have chosen to draw.

84

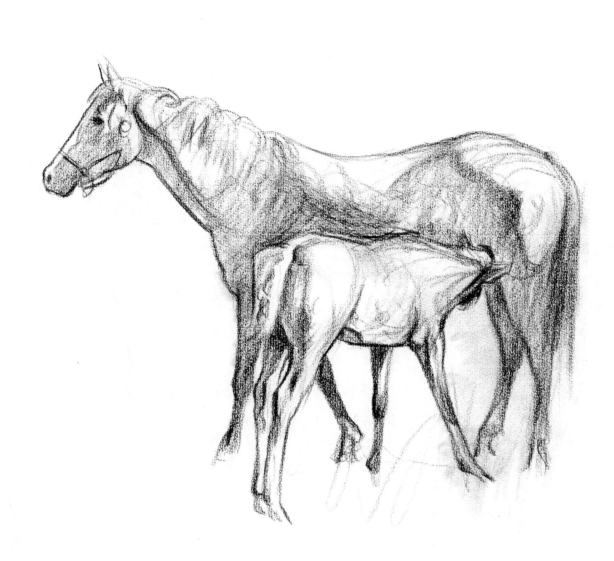

Working drawing 11 x 9½ for acrylic painting
Mare and Foal

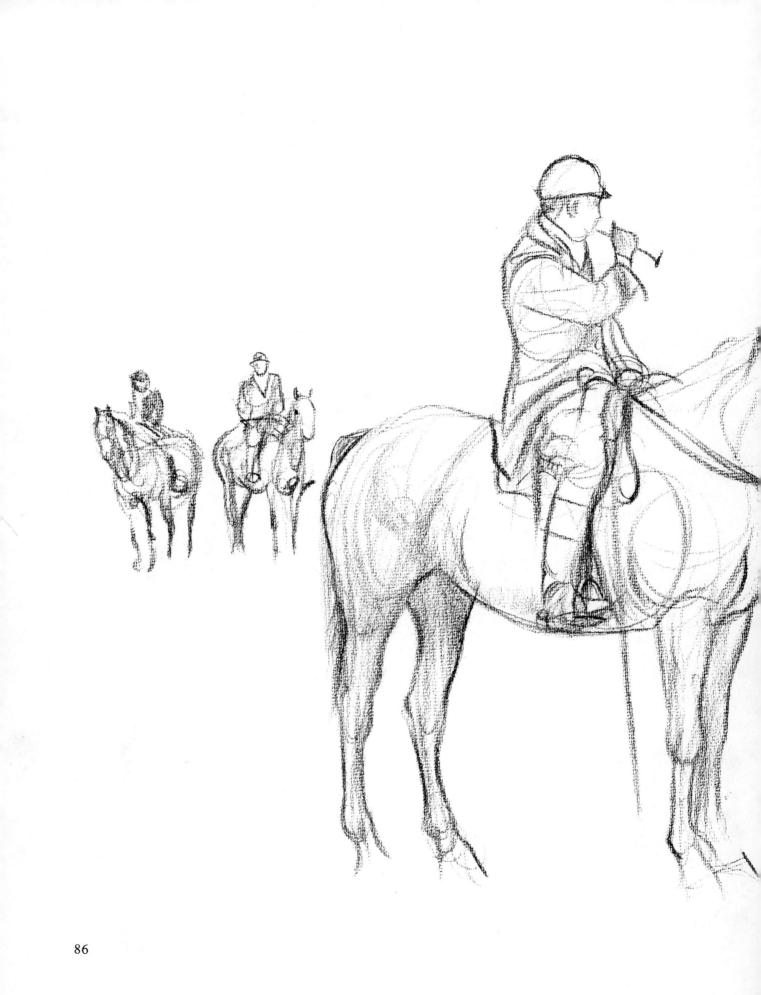

Working drawing 20 x 13 for watercolor
Genesee Hunt

In (1) the initial action lines are drawn rapidly. In (2) the plan of (1) is carried to completion. (3) leads to (4). In (5) the emphasis is on the stiff forelegged landing. (6) is the finished sketch. (7) leads to (8) and (9) to (10). The best way to study jumping or any other extreme action of a horse is through quick, on-the-spot notes, such as the two remaining small sketches. Sketching from life will get you the feel of the action more than any study of photographs will do. Action photographs help in later study of details and progressive actions.

88

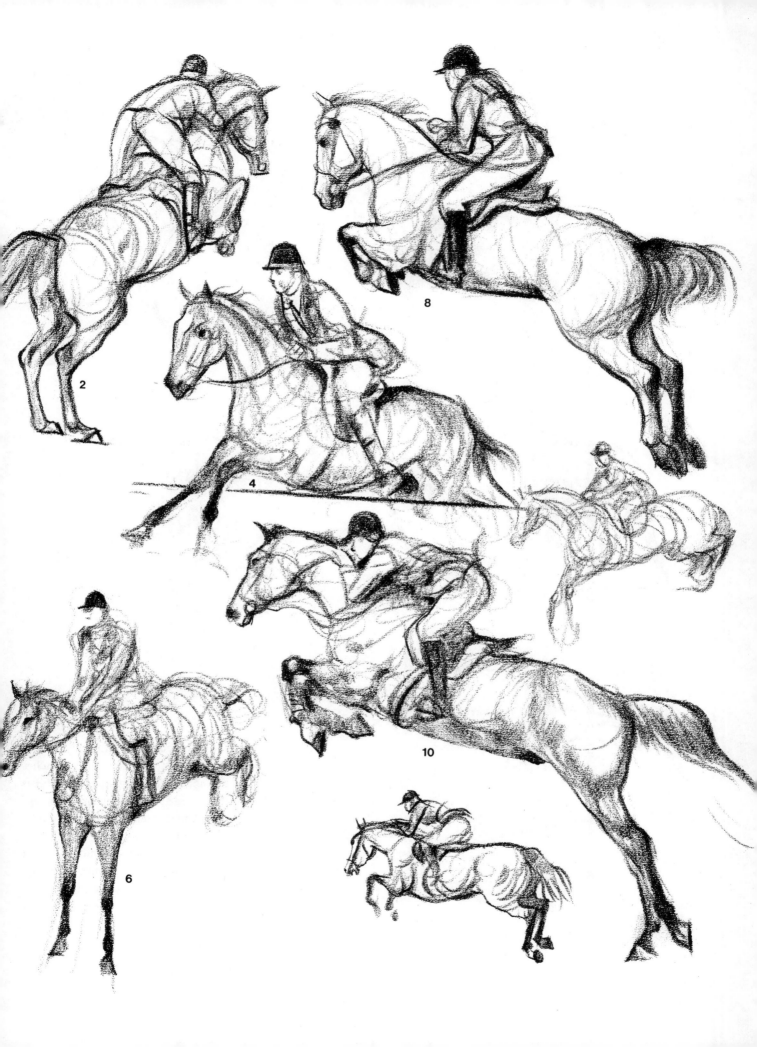

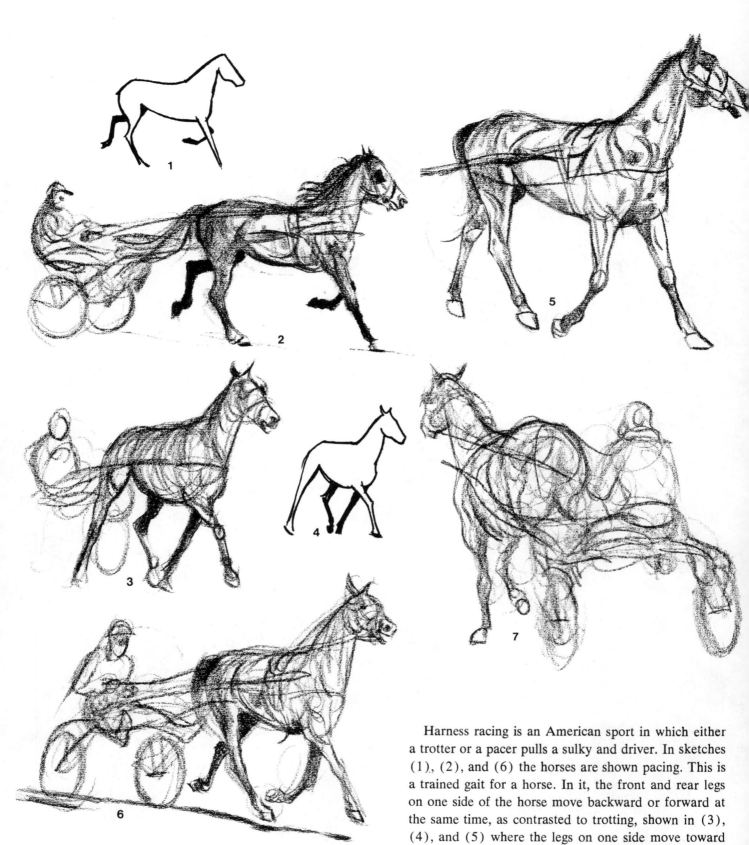

Harness racing is an American sport in which either a trotter or a pacer pulls a sulky and driver. In sketches (1), (2), and (6) the horses are shown pacing. This is a trained gait for a horse. In it, the front and rear legs on one side of the horse move backward or forward at the same time, as contrasted to trotting, shown in (3), (4), and (5) where the legs on one side move toward each other or apart at the same time. Unnatural as the pace may be, the pacers seem to make better time.

Don't sketch only profiles. Try a variety of angles such as (7).

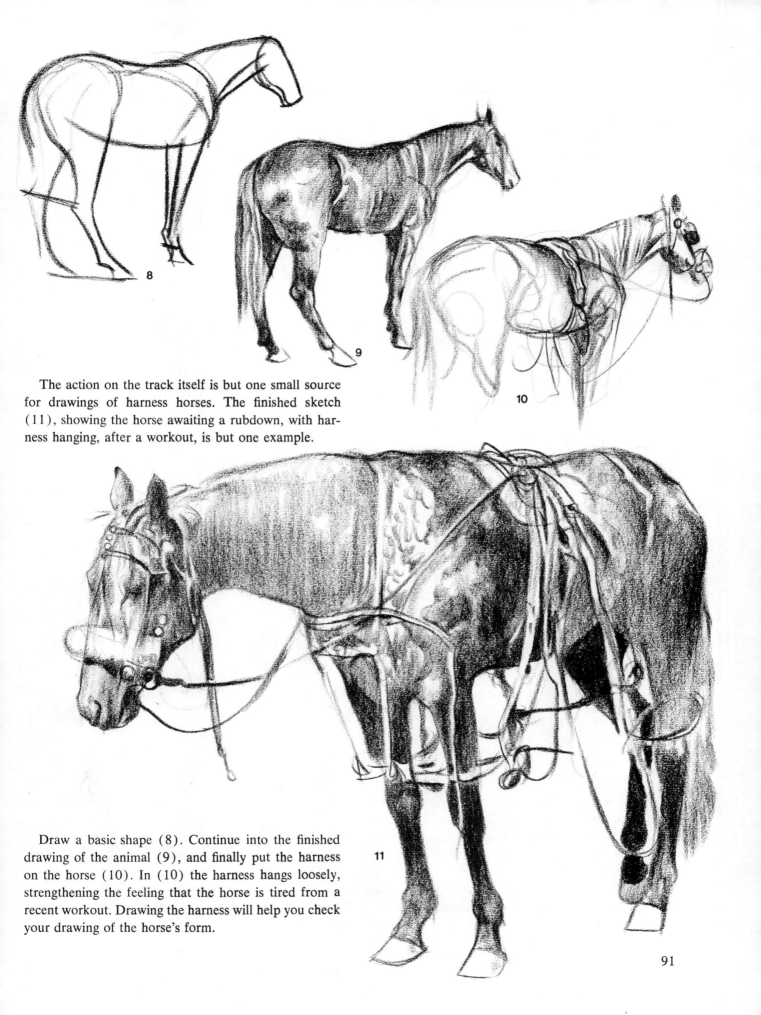

The action on the track itself is but one small source for drawings of harness horses. The finished sketch (11), showing the horse awaiting a rubdown, with harness hanging, after a workout, is but one example.

Draw a basic shape (8). Continue into the finished drawing of the animal (9), and finally put the harness on the horse (10). In (10) the harness hangs loosely, strengthening the feeling that the horse is tired from a recent workout. Drawing the harness will help you check your drawing of the horse's form.

Don't limit your drawing of horses to prize winners. Plugs make excellent subjects. This horse roamed the back roads of the Transki in South Africa, scavenging bits and pieces of practically nothing along the primitive dirt roads.

The finished sketch is quite complete, but to retain action and life in any such sketch, it is best to think and draw the simple form first as in (1) through (3).

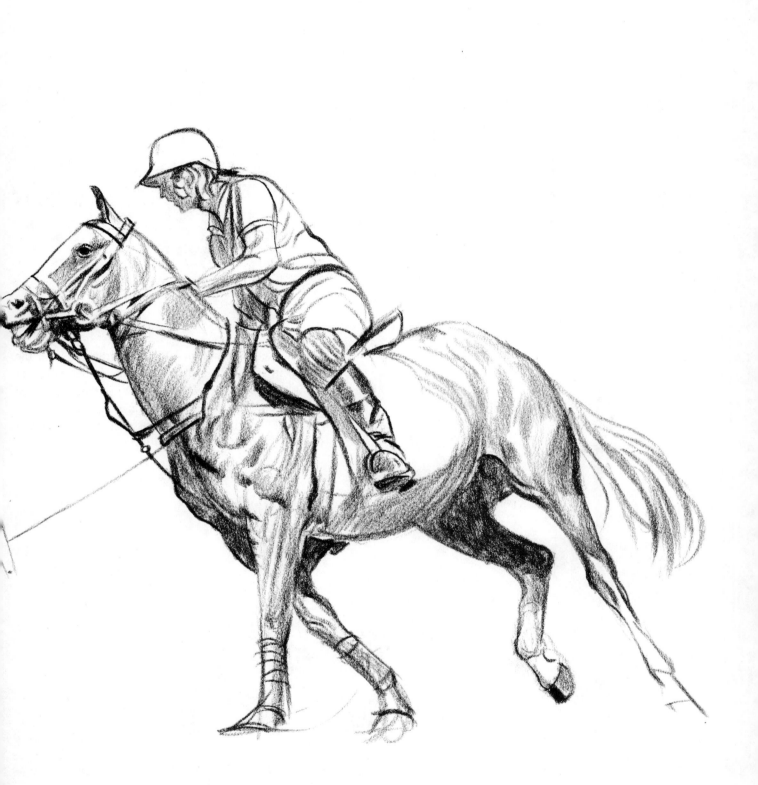

Polo is the most ancient game using a stick and a ball, and it affords the artist a rich variety of positions and actions of horses. It was first spelled "pulu," which is the Tibetan name for ball.

The horses and their movements are beautiful to watch. There is a marvelous partnership between horse and rider. Before you begin to draw, learn what the game is all about. Your drawings will benefit.

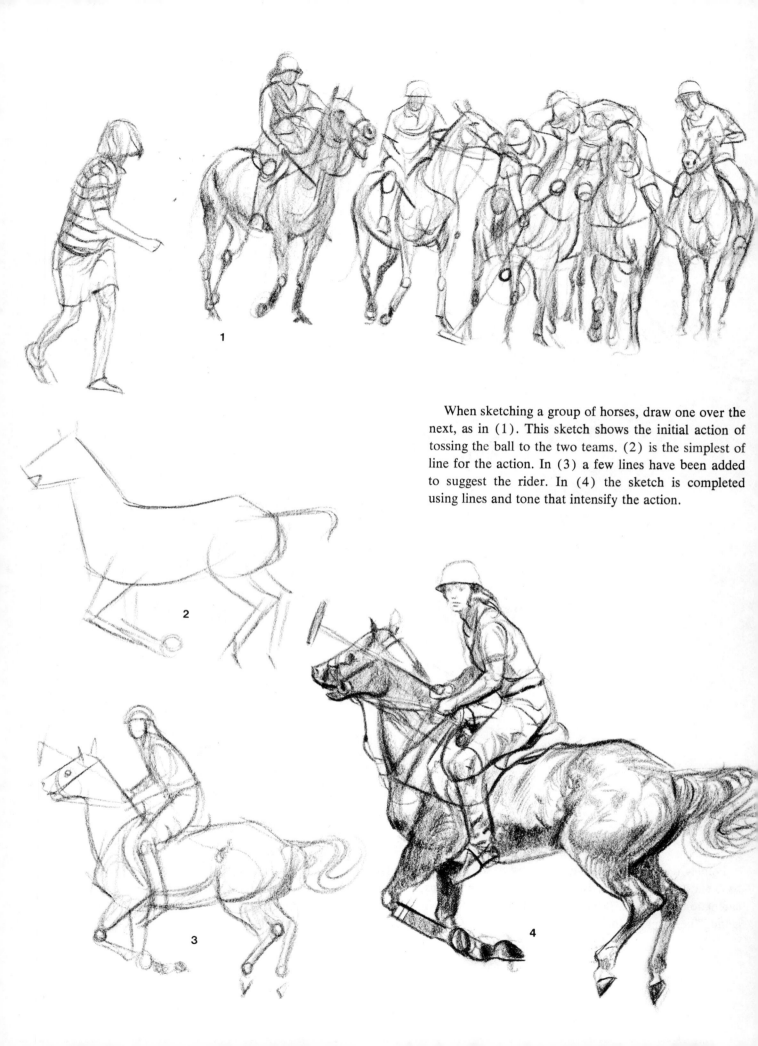

When sketching a group of horses, draw one over the next, as in (1). This sketch shows the initial action of tossing the ball to the two teams. (2) is the simplest of line for the action. In (3) a few lines have been added to suggest the rider. In (4) the sketch is completed using lines and tone that intensify the action.

1

2

3

4

From many photographs, we arrived at drawings (1)
and (3). With good photographs as a guide, we made
the studies shown in (2) and (4). Along with your
rapid action notes, it is helpful occasionally to draw fin-
ished sketches of parts of the animal or the animal as a
whole.

95

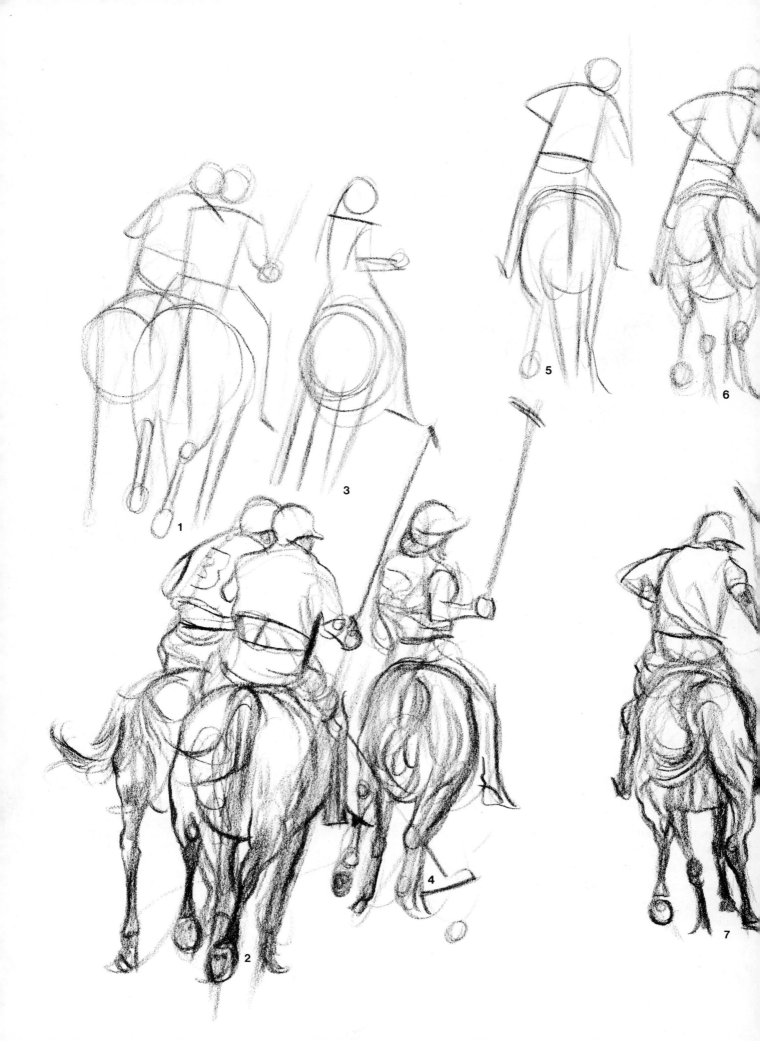

8

9

11

(1) shows the initial lines that lead to the more fin-
ished sketch (2). (3) leads to (4), (5) and (6) to (7).
(8), (9), and (10) are similar progressive steps, as are
(11), (12), and (13). The moment you have caught the
action, stop and go on to another sketch. Later, using as
reference black-and-white photographs or transparen-
cies projected on a screen, you can add more detail.

12

10

13

1

2

3

In the progressive sketches (1), (2), (3), and (4), the most important consideration is that the sketch be visualized as a unit, rather than targeting on any one animal too soon in the sketching process.

The most you can hope for in such an involved subject will be the roughest of sketches. In horse and pony pulling contests, the identical act is repeated again and again, so what you miss the first time, you may catch the second time around. Sketching on the spot develops not only your facility in drawing, but better yet, teaches you to observe and retain what you see.

4

Although the original subject was a team of ponies, the sketch was concentrated on the foreground animal. In (1) the action is caught in as few lines as possible. In (2) more action lines come into the picture and a trace of tone is indicated. (3) shows the beginning of the harness. In (4) the details are drawn. Avoid losing the action in the process.

1

2

3

4

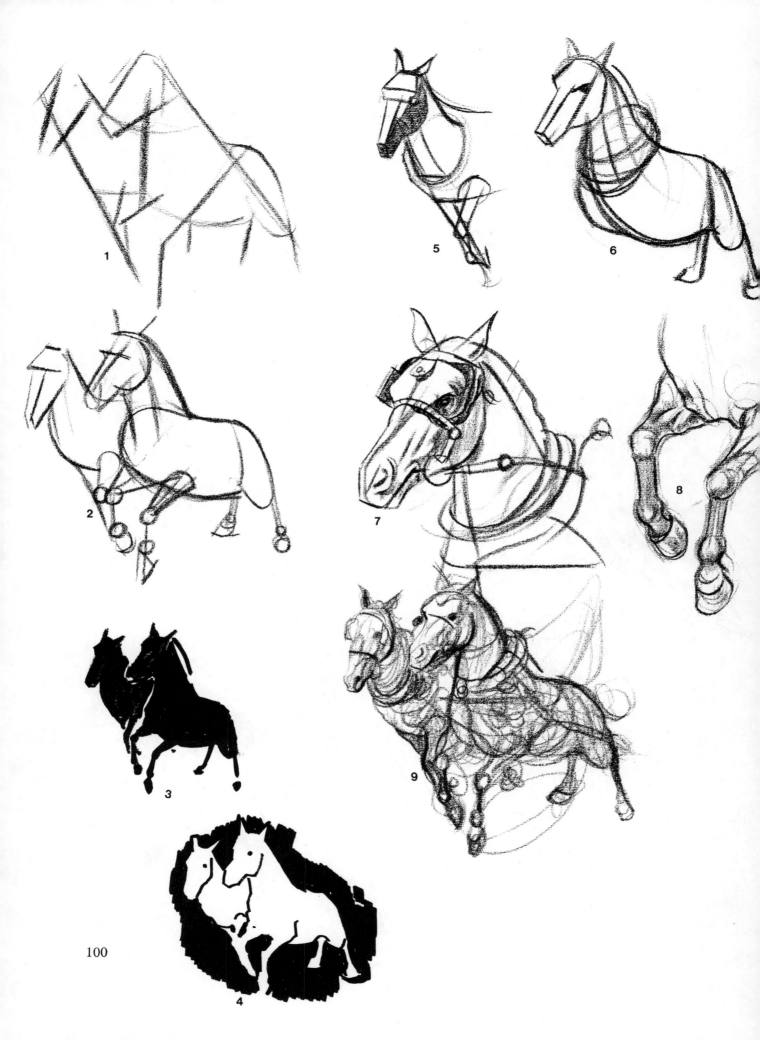

1

2

3

4

5

6

7

8

9

100

The method of drawing shown here is known loosely as "dynamic symmetry." First, a basic line is drawn. The remaining lines are quickly sketched in at compensating angles to the original (1). (2) continues with more fluid lines, using little circles to spot the joints of the legs. The silhouettes (3) and (4) point up the fact that in any drawing it is wise to analyze the spaces you are *not* drawing, as a check on what you *are* drawing. (5), (6), (7), and (8) begin the thinking on form and details. (9) is a continuous scribble-line technique over the initial stages. (10) carries the drawing to completion, to the point of including a driver.

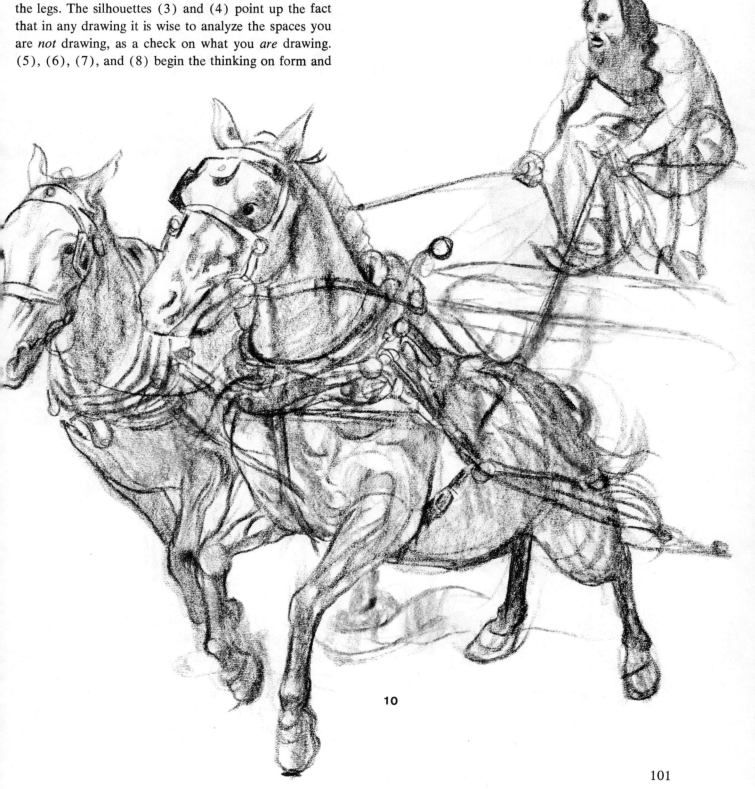

10

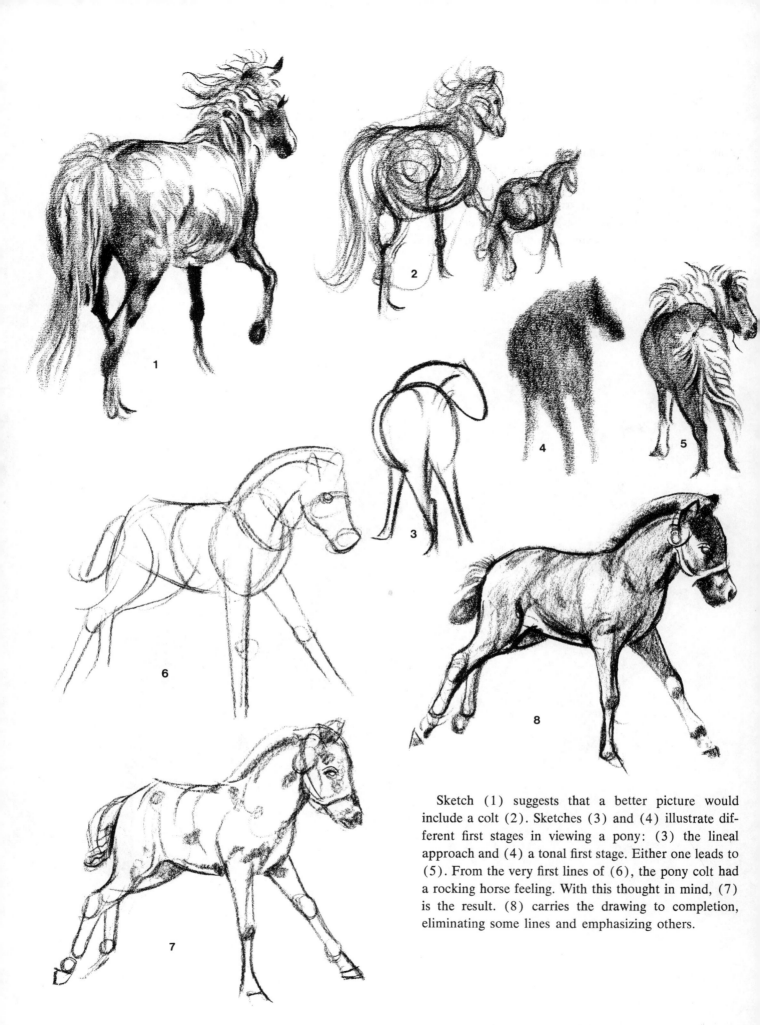

Sketch (1) suggests that a better picture would include a colt (2). Sketches (3) and (4) illustrate different first stages in viewing a pony: (3) the lineal approach and (4) a tonal first stage. Either one leads to (5). From the very first lines of (6), the pony colt had a rocking horse feeling. With this thought in mind, (7) is the result. (8) carries the drawing to completion, eliminating some lines and emphasizing others.

9 10 11

The pony and colt theme, through steps (9), (10), and (11), leads to sketch (12). In turn, this sketch later became the focal point in a finished watercolor painting.

This is an example of how one sketch builds upon another.

12

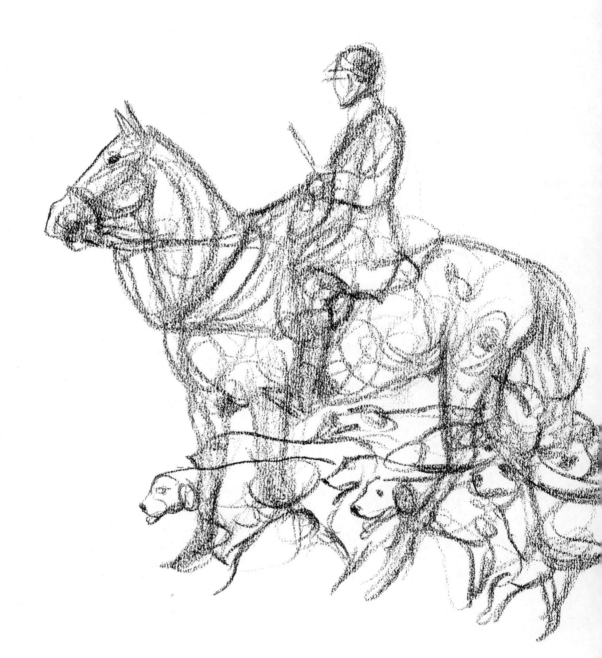

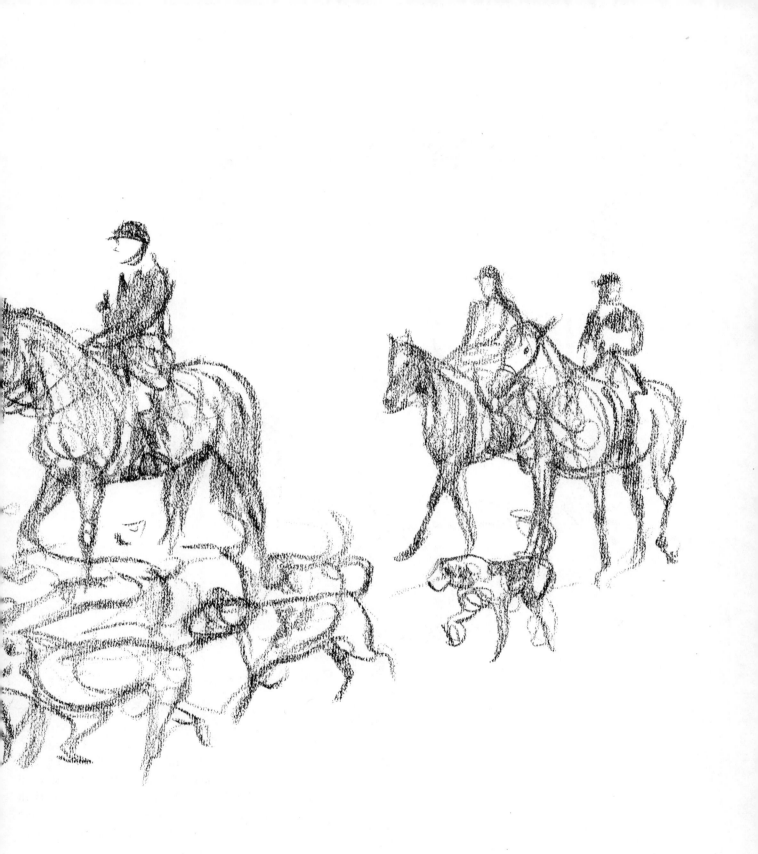

Preliminary sketch 17 x 8 for watercolor
Parade of the Couples

1

2

The skeletons are those of a cow (1) and a horse (2).
Note the differences in bone structure.

Farm Animals

For the most part, bovines have a straight backline
(3), (4), and (5), even though the Holstein (5) might
be less obvious with her strong black-and-white pattern.
(6) and (7) illustrate the initial "block" concept. The
horse, on the other hand, has a graceful and spirited
backline (8). So does the little dog (9). The goats in
(10) and (11) are examples of economy of line, as are
the sheep in (12) and (13). In the sheep (14) short,
scribbly lines indicate the texture of wool.

Goats are closely akin to sheep. Some varieties would
be difficult to tell apart except for the tail, which points
upward in goats, downward in sheep. Both sexes of
sheep usually possess horns, although the female's horns

106

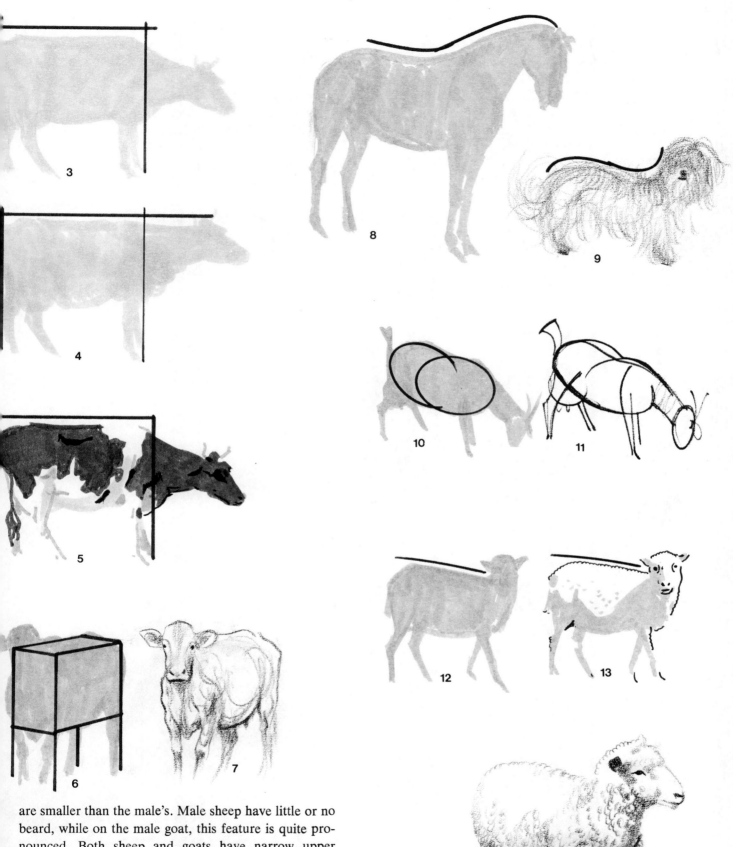

are smaller than the male's. Male sheep have little or no beard, while on the male goat, this feature is quite pronounced. Both sheep and goats have narrow upper molar teeth, in contrast to oxen. Both are essentially mountain animals, but goats enjoy the steeper slopes.

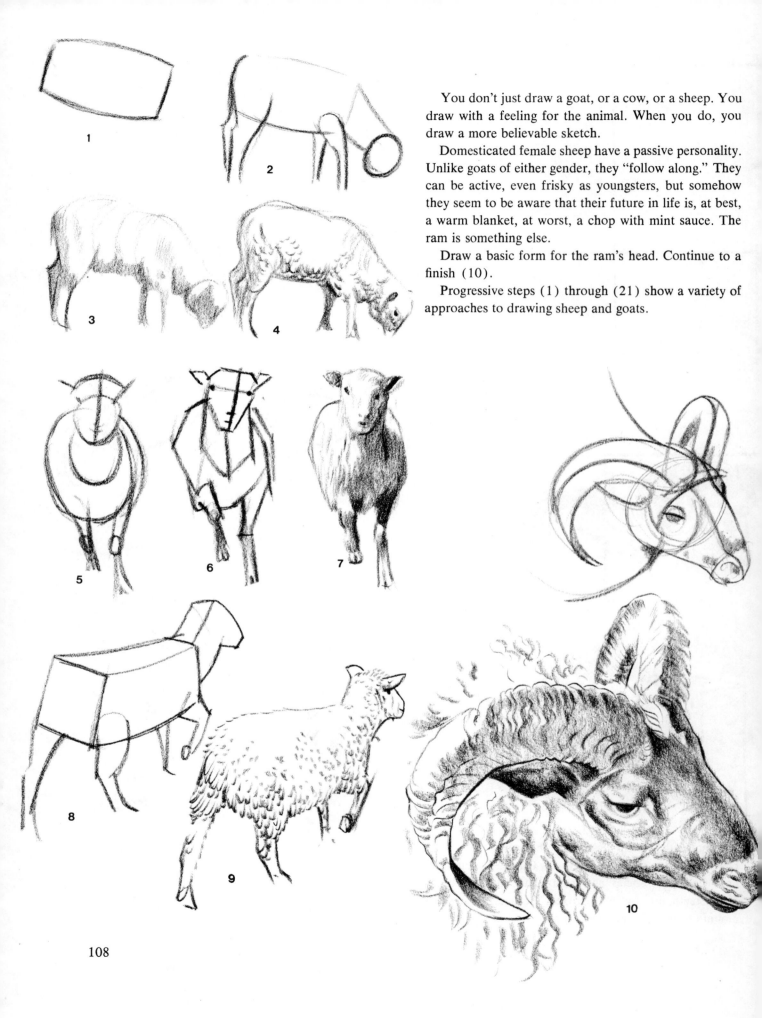

You don't just draw a goat, or a cow, or a sheep. You draw with a feeling for the animal. When you do, you draw a more believable sketch.

Domesticated female sheep have a passive personality. Unlike goats of either gender, they "follow along." They can be active, even frisky as youngsters, but somehow they seem to be aware that their future in life is, at best, a warm blanket, at worst, a chop with mint sauce. The ram is something else.

Draw a basic form for the ram's head. Continue to a finish (10).

Progressive steps (1) through (21) show a variety of approaches to drawing sheep and goats.

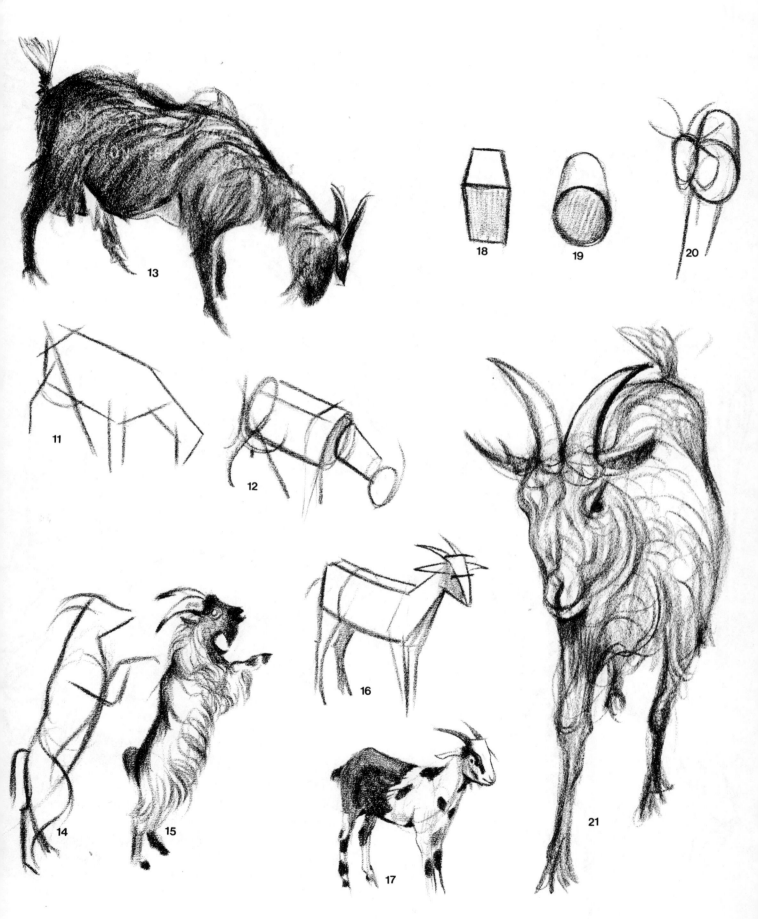

13

18 19 20

11

12

16

14 15

17

21

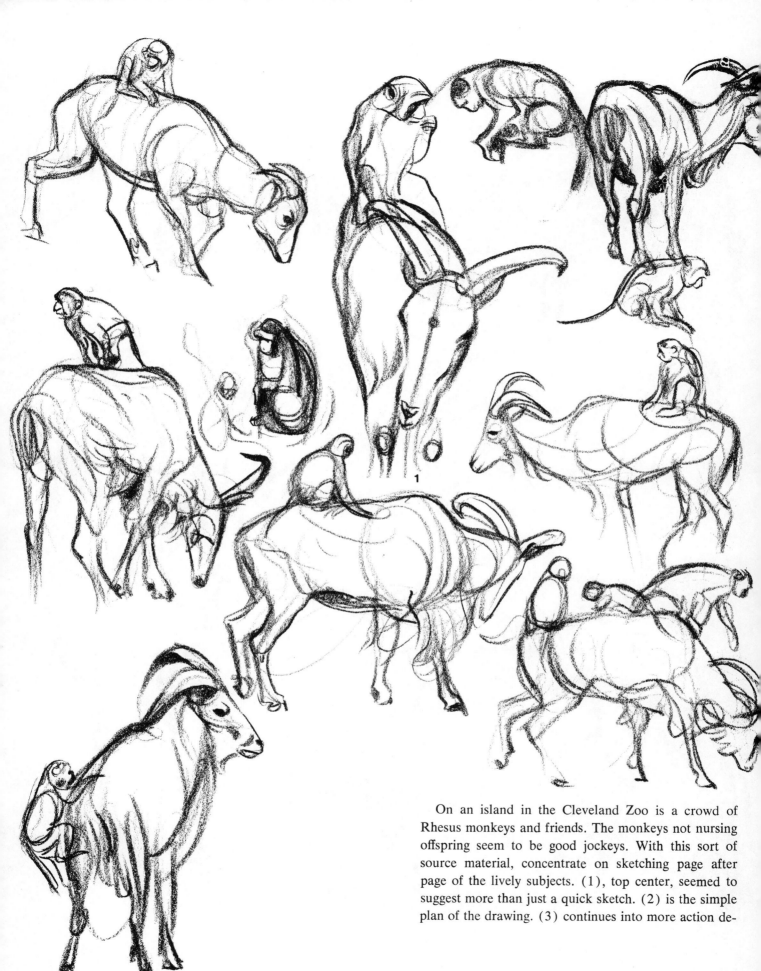

On an island in the Cleveland Zoo is a crowd of
Rhesus monkeys and friends. The monkeys not nursing
offspring seem to be good jockeys. With this sort of
source material, concentrate on sketching page after
page of the lively subjects. (1), top center, seemed to
suggest more than just a quick sketch. (2) is the simple
plan of the drawing. (3) continues into more action de-

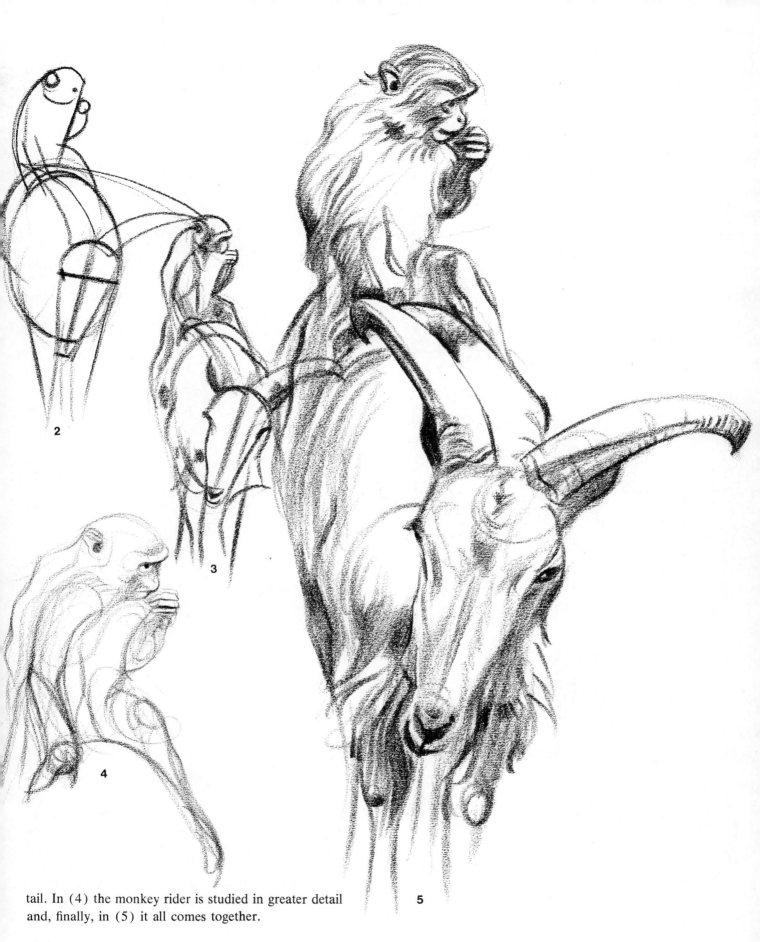

2

3

4

5

tail. In (4) the monkey rider is studied in greater detail
and, finally, in (5) it all comes together.

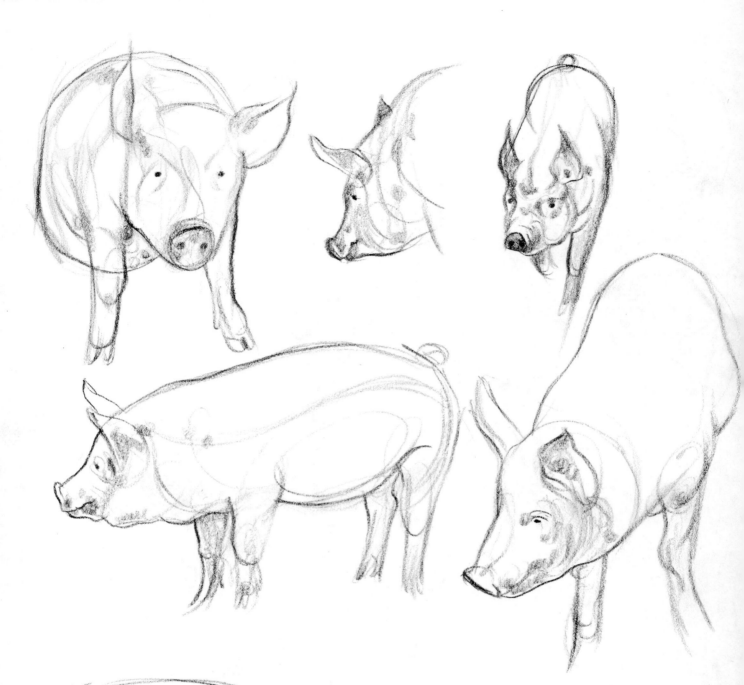

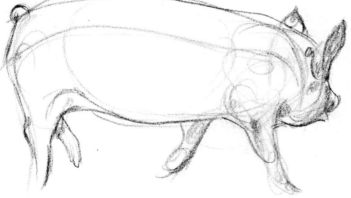

Pigs

A close, though relatively pint-sized, relative of the large hippo is the pig. The young pigs on these two pages were under 100 pounds. Draw many sketches of a given animal from many angles. Combine your sketching with the taking of photographs. Although it is good practice to be aware of the similarities and differences of different species of animals, it is wise to concentrate on one animal at a time until you have mastered the drawing of it.

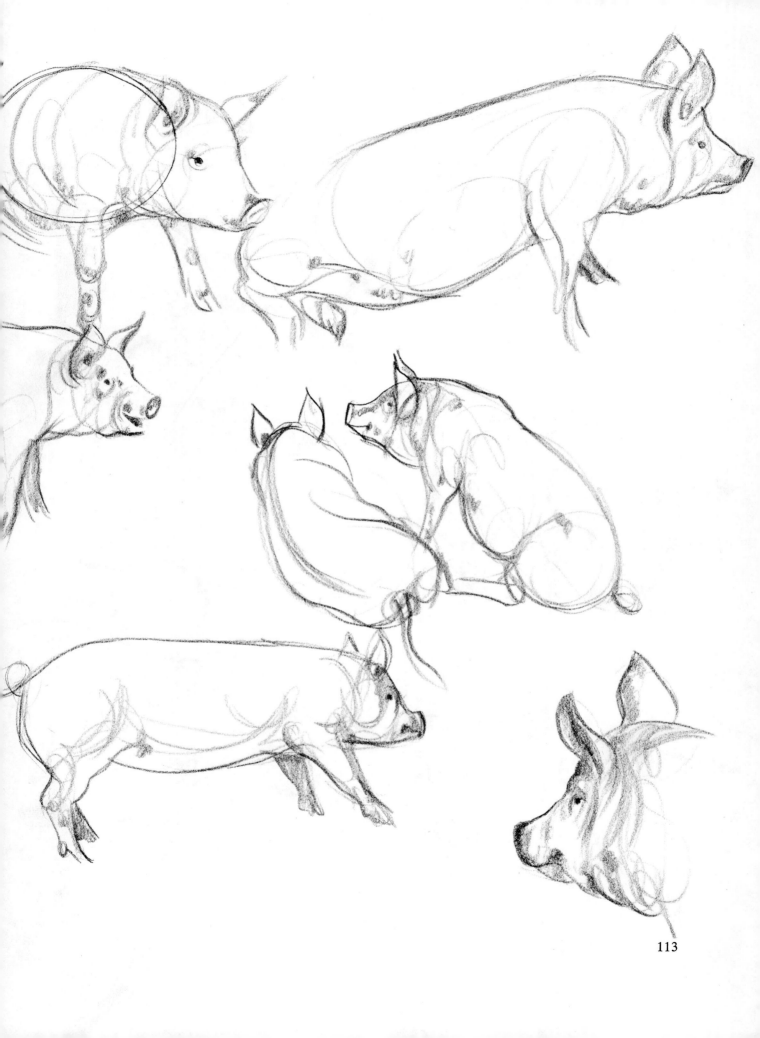

In the sketch of the group of curious cows (1), one was drawn quickly; then another and another one over the next. In (2) some of the same cows are drawn in greater detail. In (3) and (4) the pattern and design of the two cows is studied through careful drawing.

(5) and (6) illustrate a long-horned breed of cow native to Italy. The sketches stress the action and feeling for the two animals.

114

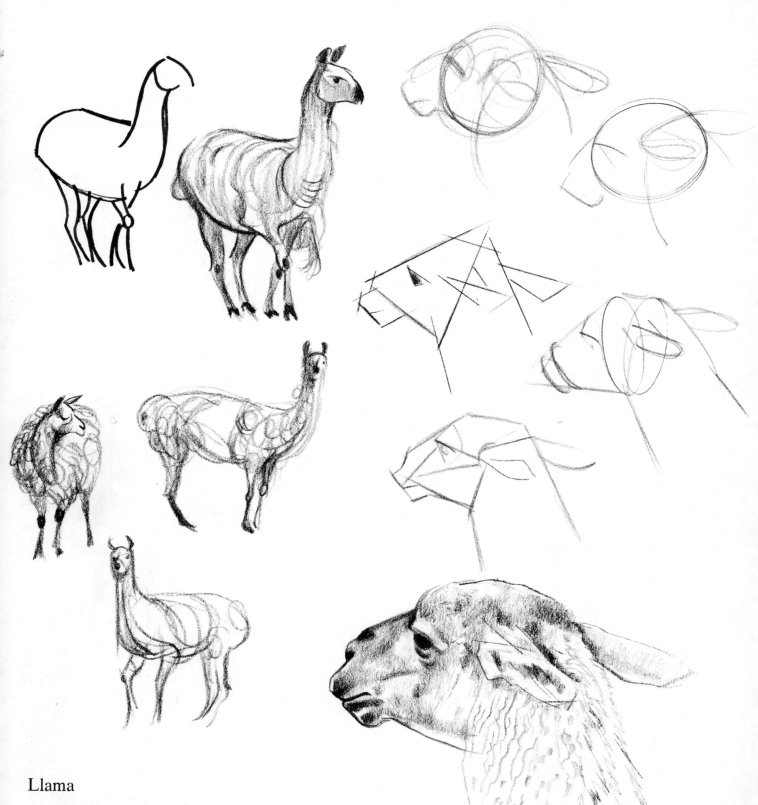

Llama

The llama is a South American member of thé camel family. An adult llama is about three feet at the shoulder.

Try drawing the llama head. Try a variety of basic shapes: a circle, an ellipse, a triangle, a cone, and a block.

115

Camels

The camel, from any angle, is a great beast to draw. Everything seems exaggerated.

Study the camel skeleton (1). It will help you to understand the animal and draw more believable sketches. In (2) only the simplest of line has been used to begin the sketch. The ragmop fur, the hump, and the incidentals are left until (3). In (4) the simple drawing seems to indicate dividing the camel in half. In (5) only the basic shadow tone has been used along with a dot for the eye. (6) is a simple line interpretation. In (7) a single, almost flat tone has been added along with indications of hooves, eye, and fur.

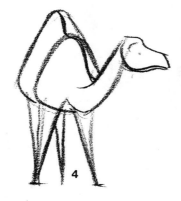

116

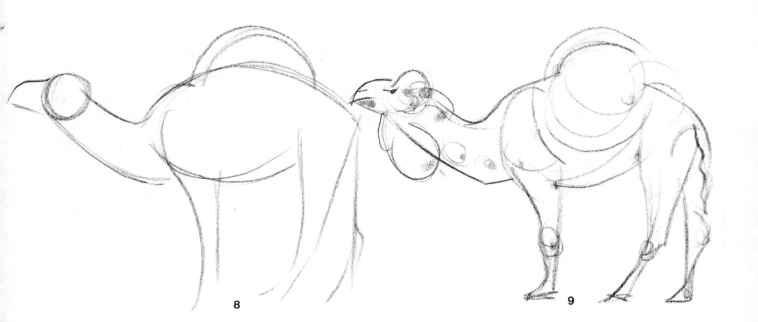

8

9

10

(8) was drawn, for the most part, with an ellipse template. (9) brings into focus important identifying areas. (10), the final drawing, is complete only to the point that it tells the story of the camel. What the artist leaves out is often more important than what he puts in.

Giraffes

At one time, the giraffe was called a "camelopard" because it had a neck resembling a camel's and spots like a leopard. Knowledge of the similarities between camel and giraffe helps in drawing either one. Step (1) is the most direct of simple lines. In (2) the lines are strengthened and corrected, and in (3) the form is indicated through shadow, pattern, and detail.

The sketch (4) is drawn as though the giraffe were transparent—the neck and the body, front and back, are both shown. In (5) the merest indication of light and shade, with emphasis on the overall surface pattern, is added.

(6) illustrates the rather startling position taken by giraffes while drinking. (7) merely completes the sketch.

(8) is a close-up of the beast, showing the details, the long eyelashes, and the furry horns.

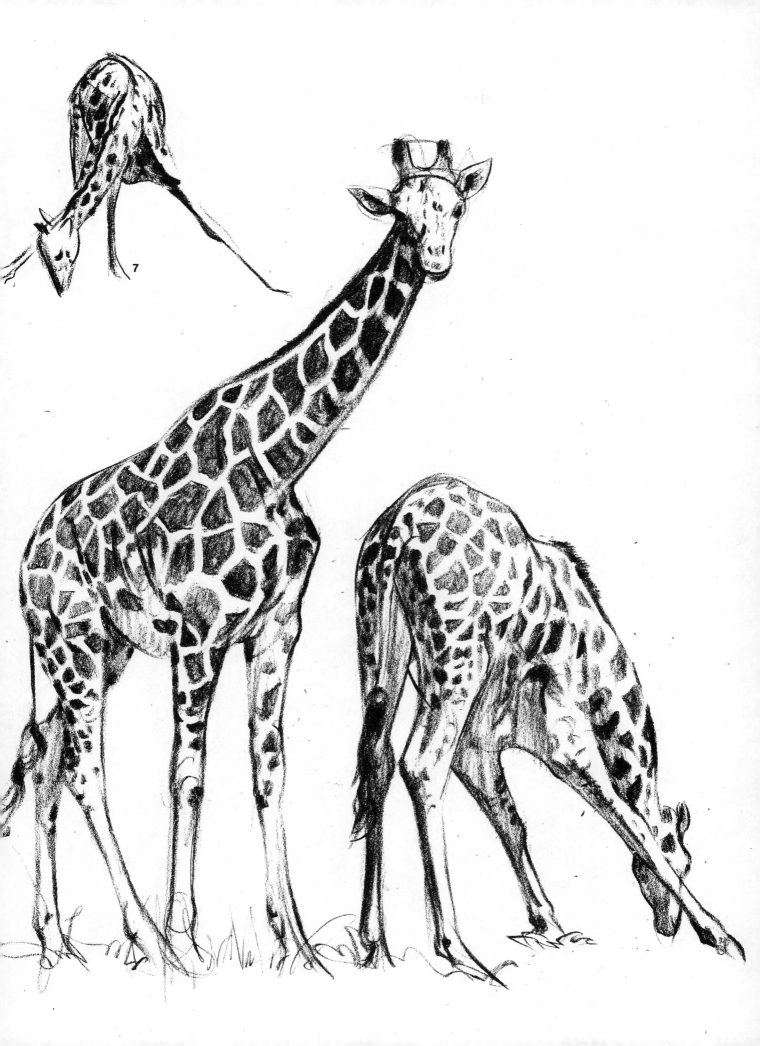

7

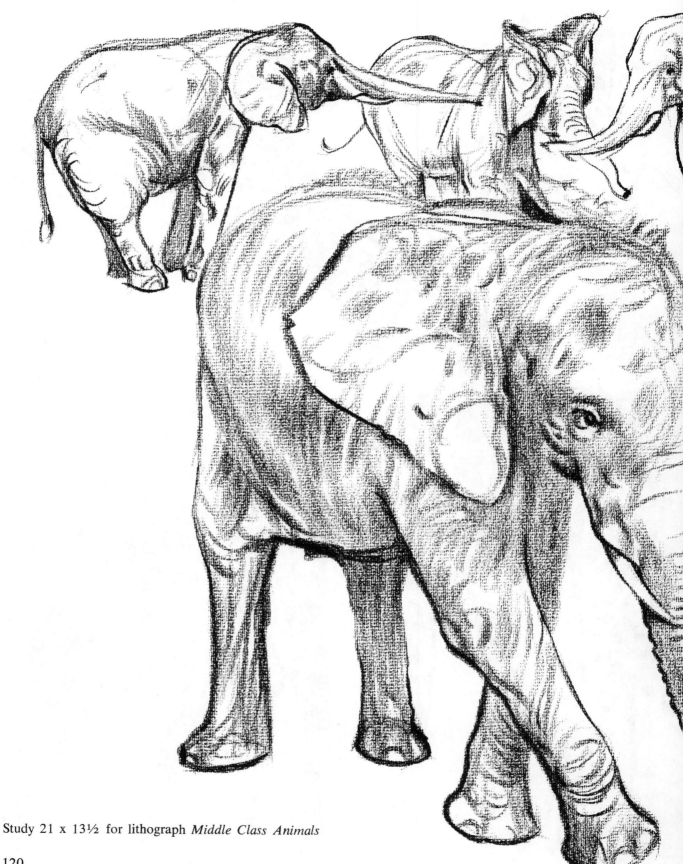

Study 21 x 13½ for lithograph *Middle Class Animals*

120

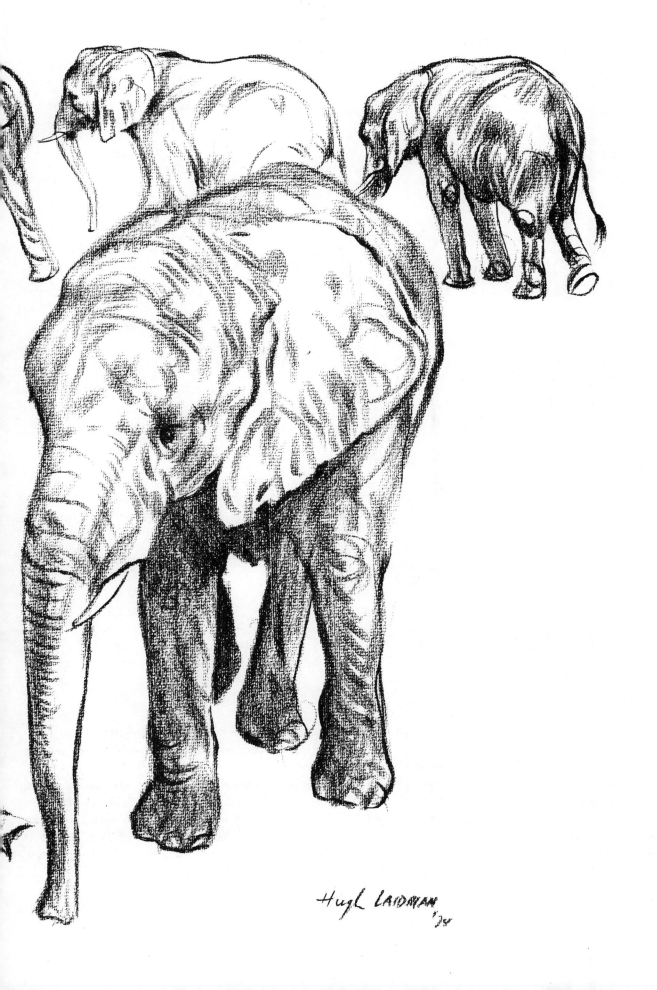

Hugh LAIDMAN
'75

121

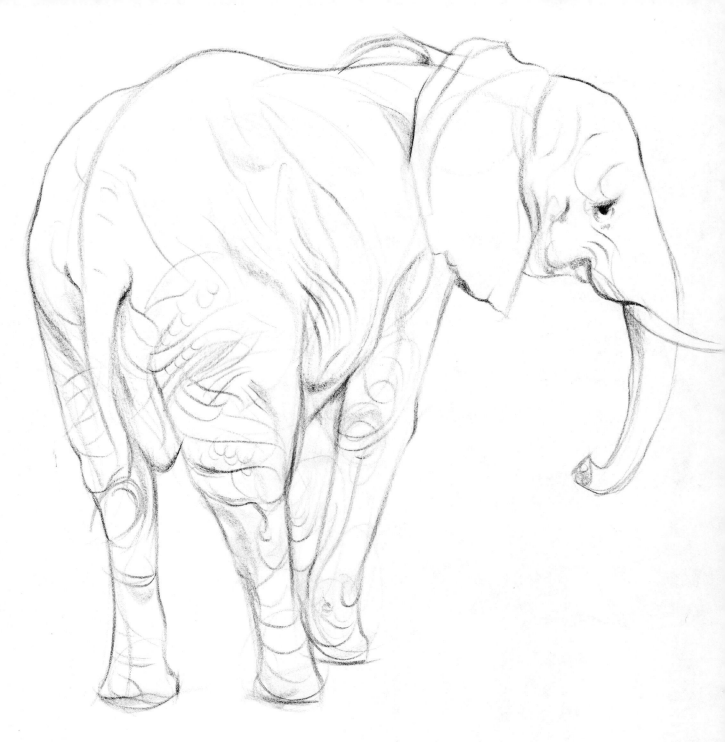

Elephants

The elephant has long been a favorite subject for the artist.

Starting with a simple oval (1), a head and four legs are indicated simply (2). In (3) the details start. If it weren't for all the preliminary ovals showing, this could be a fairly complete sketch at this point. (4) is a partial tone approach, still starting with the simple oval. (5) through (9) all begin with the same basic oval, even though the animals are in widely differing attitudes and positions. Somehow, the elephant, even as a baby, (10) and (11), lends itself singularly well to the oval approach.

Indian elephants have smaller ears and a slightly different silhouette from African elephants. The adult African elephant weighs between 6 and 7 tons, and surprisingly, can charge at a speed of 25 mph. The Indian elephant is generally smaller and has been domesticated in his native land.

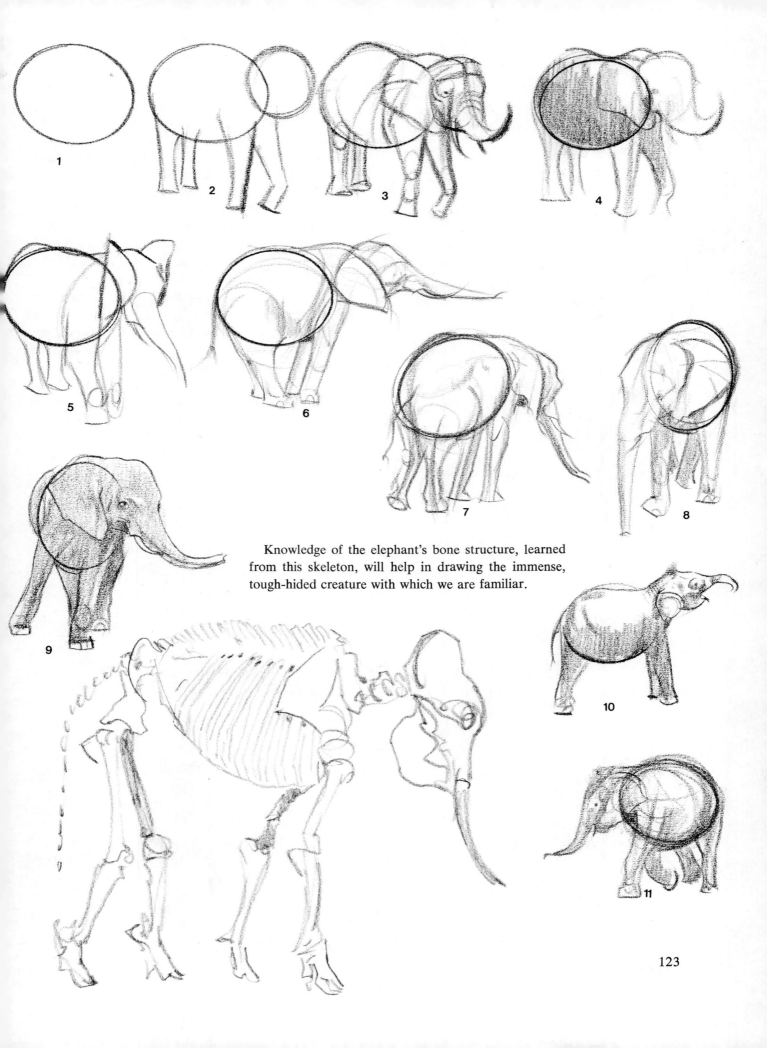

Knowledge of the elephant's bone structure, learned from this skeleton, will help in drawing the immense, tough-hided creature with which we are familiar.

123

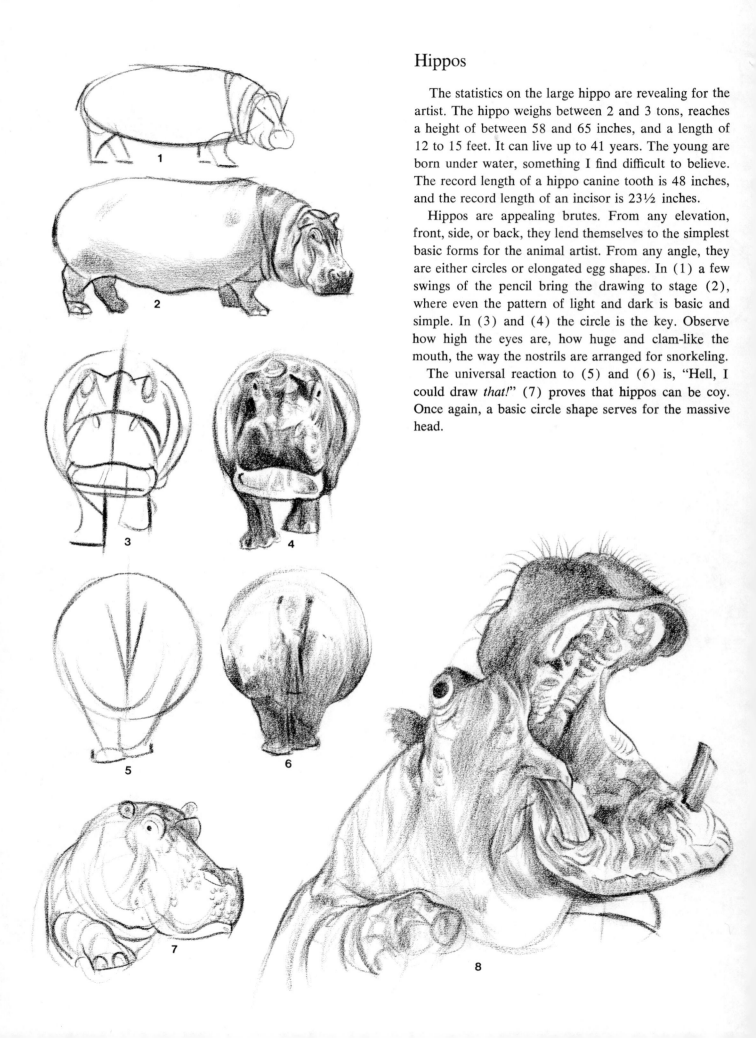

Hippos

The statistics on the large hippo are revealing for the artist. The hippo weighs between 2 and 3 tons, reaches a height of between 58 and 65 inches, and a length of 12 to 15 feet. It can live up to 41 years. The young are born under water, something I find difficult to believe. The record length of a hippo canine tooth is 48 inches, and the record length of an incisor is 23½ inches.

Hippos are appealing brutes. From any elevation, front, side, or back, they lend themselves to the simplest basic forms for the animal artist. From any angle, they are either circles or elongated egg shapes. In (1) a few swings of the pencil bring the drawing to stage (2), where even the pattern of light and dark is basic and simple. In (3) and (4) the circle is the key. Observe how high the eyes are, how huge and clam-like the mouth, the way the nostrils are arranged for snorkeling.

The universal reaction to (5) and (6) is, "Hell, I could draw *that!*" (7) proves that hippos can be coy. Once again, a basic circle shape serves for the massive head.

1

2

3

4

5

6

7

8

10

13

11

12

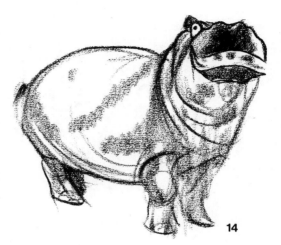

14

9

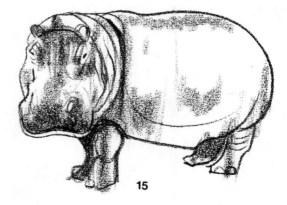

15

In the zoos, you will see hippos in many poses. If they are just out of the water, make them shiny.

For fun, take huge newspaper sheets and make large crayon sketches of any of the animals. Take the hippo first. It poses well and is relatively easy to draw.

In the Philadelphia Zoo, there is a lady hippo named Sub-Marie, and with little or no encouragement, she will open her mouth (8). Note in (9) the directional lines connecting the upper and lower portions of the huge mouth. Proper construction is important in such an impossible beast. It is always a good idea to keep these construction lines in until near the finish of the drawing.

Hippos stay mainly in water, except in the cool of the evening. Any animal partly submerged must be drawn as though you were looking through the water (10). In the initial stages of the drawing, the lines must follow around into the water. Once you have finished, (10) and (11), the design of the water, turbulence and the waves, combined with reflections, and sometimes transparence, all come into play (12).
Draw (13), (14), and (15), beginning with basic shapes and continuing into finished sketches.

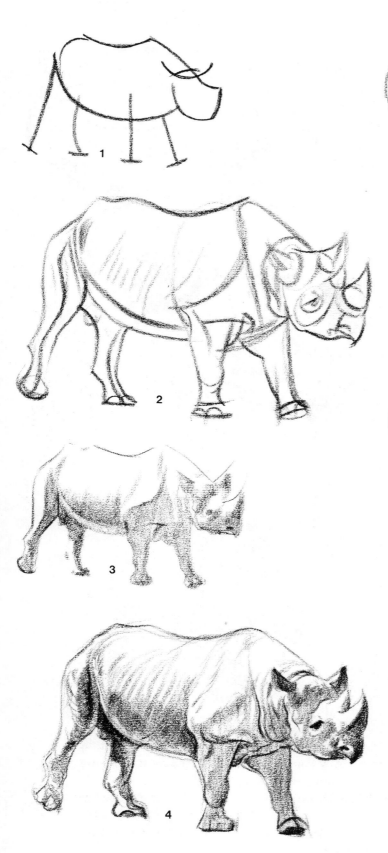

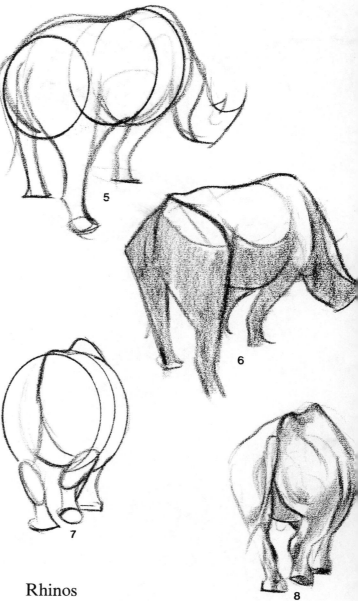

Rhinos

The Indian rhinoceros has one horn, the African, two. These horns are composed of compacted, modified hair. The Indian variety has warty armor plate-like skin which grows in deep folds. The African rhino has a relatively smoother appearance. There are two main subspecies of the African variety: the white rhino, which isn't white and weighs up to 3½ tons, and the black rhino, which isn't black and weighs between 1½ and 1¾ tons. The black rhino is distinguished, if you wish to consider any rhino distinguished, by a pointed, prehensile lip.

All rhinos are rather stupid and ill-tempered. They make up for poor eyesight with acute hearing and the assistance of small far-sighted bird friends who ride on their backs and warn of intruders. All rhinos are best observed in captivity, or through a strong set of binoculars.

All of the animals on page 126 are black rhinos. In (1) we begin our sketch with a stick figure and continue into more definitive line, following through with (2). (3) is a simple tonal interpretation of the same drawing. In (4) the detail has been carried a bit further, a few black accents, and indications of underlying skeletal structure. (5) is a series of quick oval shapes, with a fluid line approach for legs and other details, emphasizing the action. (6) is the same basic sketch, this time limiting our approach to basic tonal pattern. An excellent way to practice simple tone drawing is to use a medium gray Magic Marker. The rear view of the rhino (7) points up the advantage of using the simple oval shape as a beginning. Once this is accomplished, it is relatively simple to think in terms of basic tone as in (8).

Note the differences between African and Indian rhinos. (1), (2), (3), (4), (5), and (6) are Indian. (7), (8), and (9) are African. The African rhinos shown are black rhinos. The white African rhino, which is extremely rare, is characterized by his broad, square, upper lip and is sometimes called the "square-lipped" rhino.

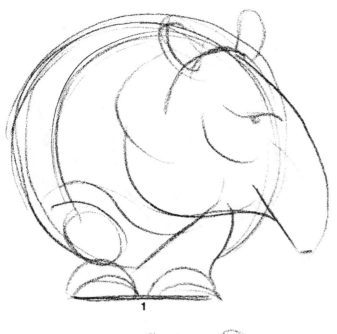

1

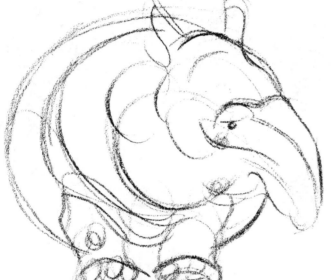

2

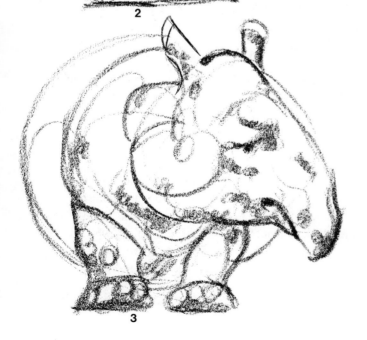

3

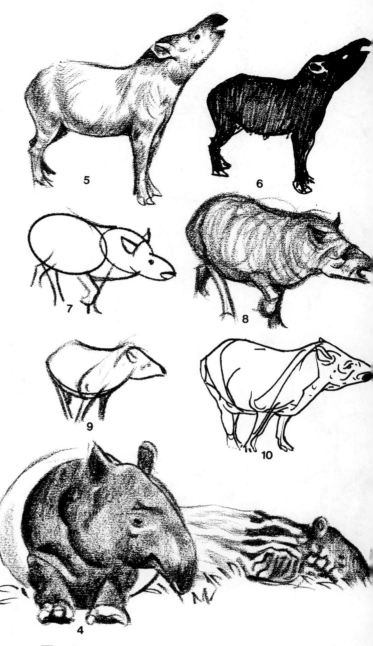

5

6

7

8

9

10

4

Tapir

The tapir has roughly the conformation of a husky young domestic pig, but is considerably larger. A large adult may be 3½ feet at the shoulder and weigh 600 pounds. The tapir has four toes on his front feet and three on his rear feet. In some varieties the young look like a striped watermelon. The snout, as mentioned earlier, is a much shortened version of the elephant's trunk.

Viewed from the front (1), (2), (3), and (4) he presents a circular design. From the side he looks like a young pig (5) and (6). In (7) a couple of ovals have been used to bring us to (8). In (9) the action swing lines become the basis for a simple line interpretation (10).

Deer and Antelope

Antelopes, in their wild state, are Old World animals. In some species, both male and female carry horns, as opposed to deer, where only the male has antlers. Elk and deer shed and re-grow a set of antlers annually.

1

(1) is the skeleton of an antelope. (2) is a deer. Note the similarities and differences. Since white-tailed deer lose their antlers in the spring and do not regain their full rack until the following spring, you should remember this whenever you draw a white-tailed deer in a seasonal landscape.

2

The Siberian reindeer, (1) through (7), of both sexes bear tremendous, haphazard antlers. They have been domesticated in Europe and Asia and imported into Canada and Alaska. The caribou of the United States and Canada is a New World variety.

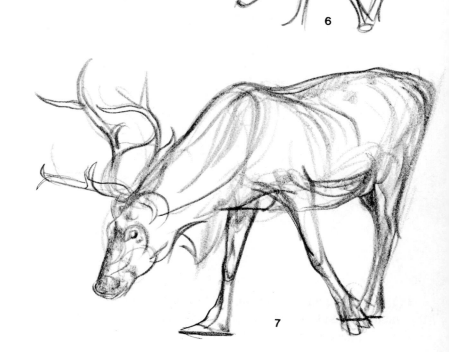

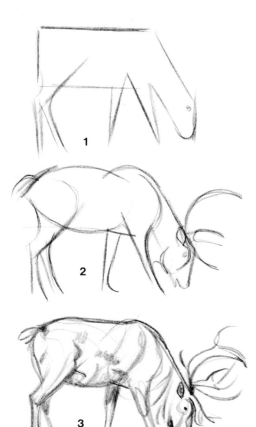

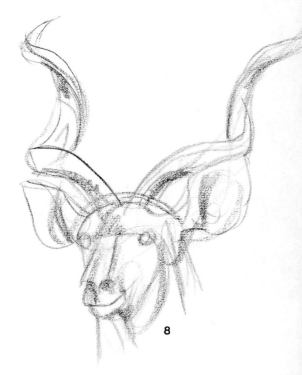

Sketch (1) shows a box-like approach to the final drawing (3). Sketch (2) is an intermediate step. Sketch (4) is a box-like approach leading to (5). In (6) a swinging line has been used to emphasize the action in final sketch (7). (8) illustrates the distinctive spiral horns of the kudu, an antelope of Africa.

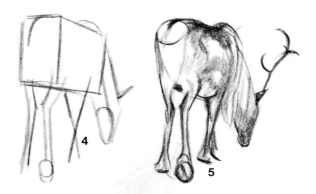

(1) through (6) are gemsboks. This animal can survive without water for months on end. It weighs between 400 and 465 pounds, and lives some twenty years. Of interest to the artist is its extremely strong, black-patterned body and legs. Its head is antlered with distinctive straight horns. The record horn length is 48 inches.

(7) is a kudu, (8) a bongo, and (9) the largest of all antelopes, the eland. Draw these three, using the procedure shown with the gemsbok.

131

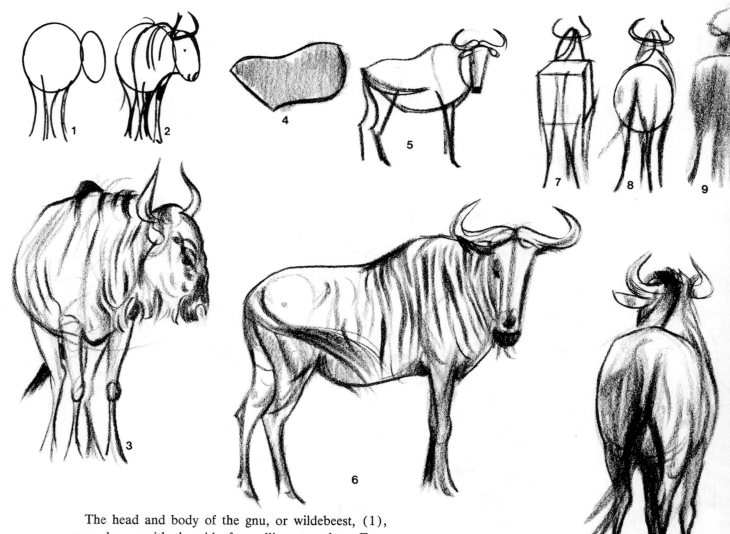

The head and body of the gnu, or wildebeest, (1), were drawn with the aid of an ellipse template. Four freehand lines indicate legs. In (2) the major action lines begin to show. In (3) details, eyes, stripes, mane, whiskers, and a strengthening of action lines make a complete sketch.

(4) indicates a tonal mass of the body of the gnu. (5) shows the line of the action, with the lines "going through." In (6), and not before, details, accents in darker line, and a slight indication of light and shade come into the picture. (7) is a cube approach, (8) is the circle or ellipse beginning, and (9) is a tonal shape start—in this case, the shadow mass. When drawing from life, it helps to squint your eyes to determine the mass shape. (10) is the final sketch, whether we began with (7), (8), or (9).

The action of the gnu running, (11), (12), and (13), shows a less obvious use of basic shapes, but basic shapes nonetheless. Many lines are rapidly sketched. As the artist proceeds, he chooses and accents the lines that tell the story best. (6) is a characteristic position of a curious gnu, first sketched in the jungle.

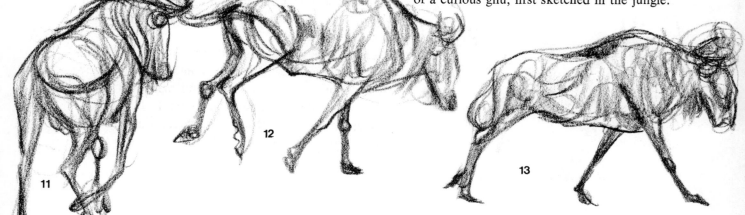

1

2

The gnus (1) demonstrate the use of strong flowing lines to catch the action. The term "action" does not necessarily describe violent movement, but rather a feeling of movement in the lines themselves. (2) shows how you can portray the animal by omitting, rather than fully completing, some of its parts.

133

The moose is the largest of the deer family. It has a short neck, long legs, and a long, fleshy muzzle. Moose have tremendous antlers, resembling a hand with the fingers spread. (1), (2), and (3) were drawn from a stuffed moose head. In (1) the attention was on the simple geometry of the form. (2) is a line interpretation, and (3), a finished drawing. It is wise to make a number of sketches in varied techniques while studying.

The sketches of the moose standing, (4), (5), and (6), were made later from slide projections. The stuffed head proved to be inaccurate in muzzle conformation. In drawing any animal, work from as many sources as possible.

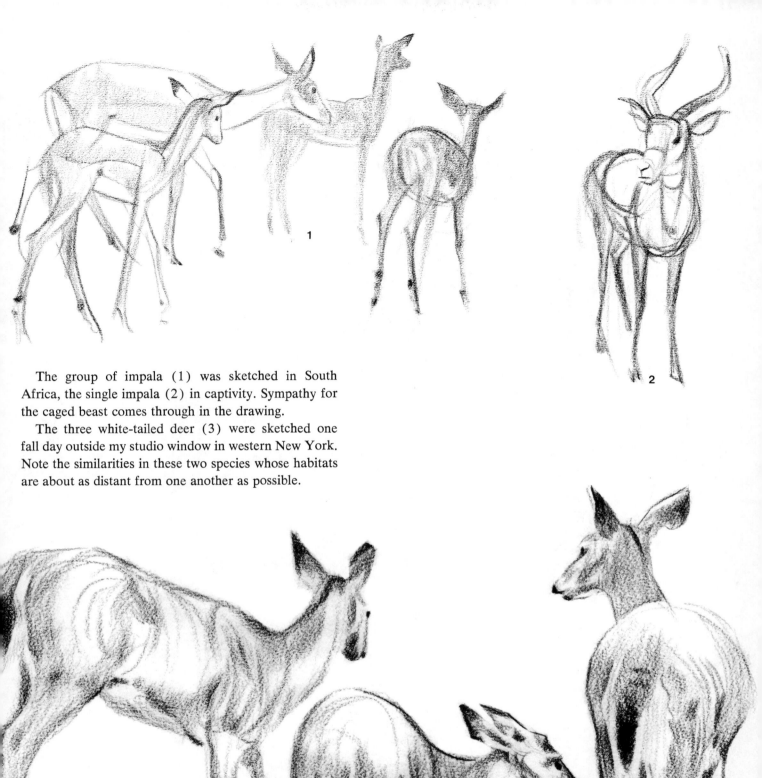

The group of impala (1) was sketched in South Africa, the single impala (2) in captivity. Sympathy for the caged beast comes through in the drawing.

The three white-tailed deer (3) were sketched one fall day outside my studio window in western New York. Note the similarities in these two species whose habitats are about as distant from one another as possible.

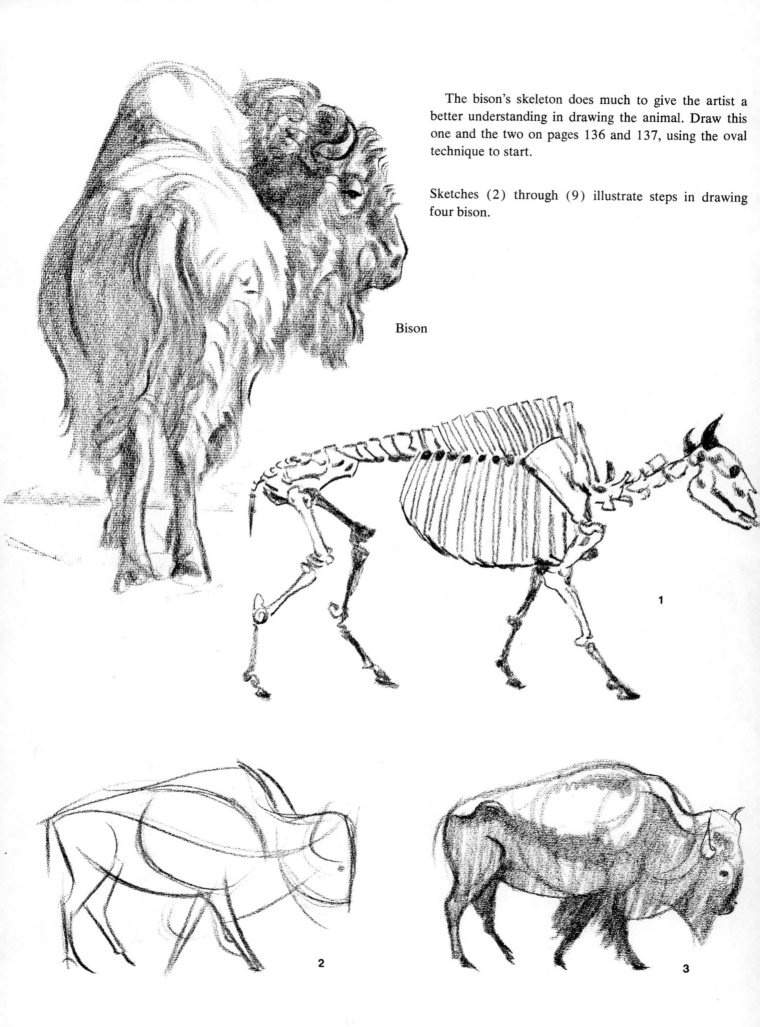

The bison's skeleton does much to give the artist a better understanding in drawing the animal. Draw this one and the two on pages 136 and 137, using the oval technique to start.

Sketches (2) through (9) illustrate steps in drawing four bison.

Bison

1

2

3

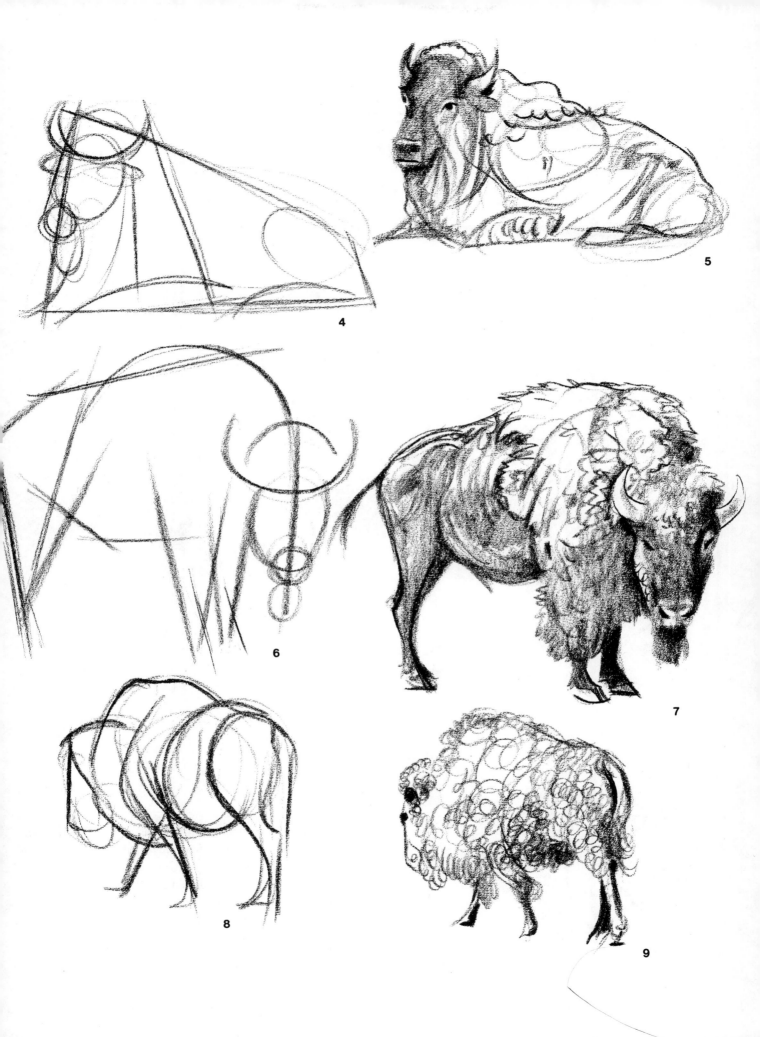

4

5

6

7

8

9

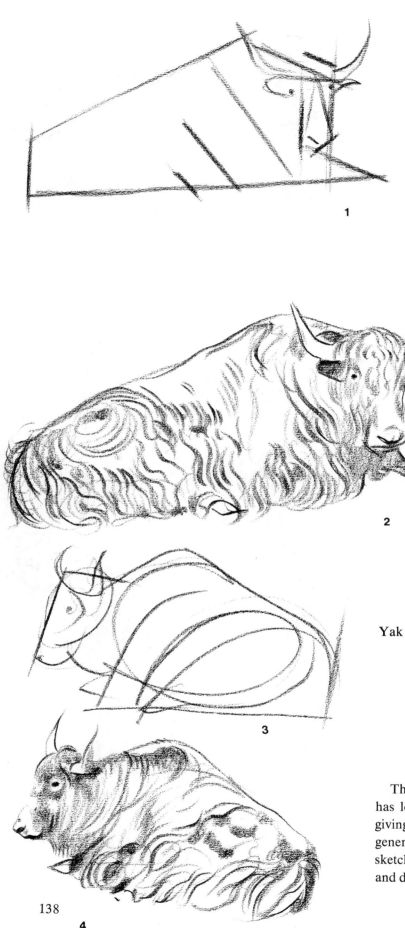

1

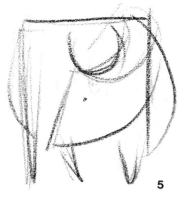

5

2

6

Yak

3

The yak is a species of ox related to the bison. He has long hair growing from his flanks and underbody giving him a square-appearing profile. This hair is generally less matted than that of the bison. As you sketch the progressive steps, look for the similarities and differences between the two.

4

Kangaroos

Huge, egg-shaped body, tremendous platform-like hind legs, heavy, powerful tail, miniature, relaxed forelegs, and oversized ears—such are the physical characteristics of the kangaroo that make it a favorite subject for drawing.

In steps (1) through (3) the features have been indicated quite realistically, but the form and fluidity would allow for much more exaggeration. On-the-spot sketches (4) are invaluable for later drawing with photographs, which are almost a "must" in drawing this active beast.

139

Anteaters

The giant anteater of South America is a toothless animal with long stiff hair to protect its body against ant bites. It has huge claws, singularly adapted to opening ant hills. With these facts in mind, sketch the animal, first with little quick scribbles (1), then in simple tones (2) and (3), followed by concentration on details of the animal (4). The object of (5) and (6) is to establish a basic design of the animal. (7) through (9) show progressive steps, using one of the original quick sketches as a base.

1

2

3

4

5

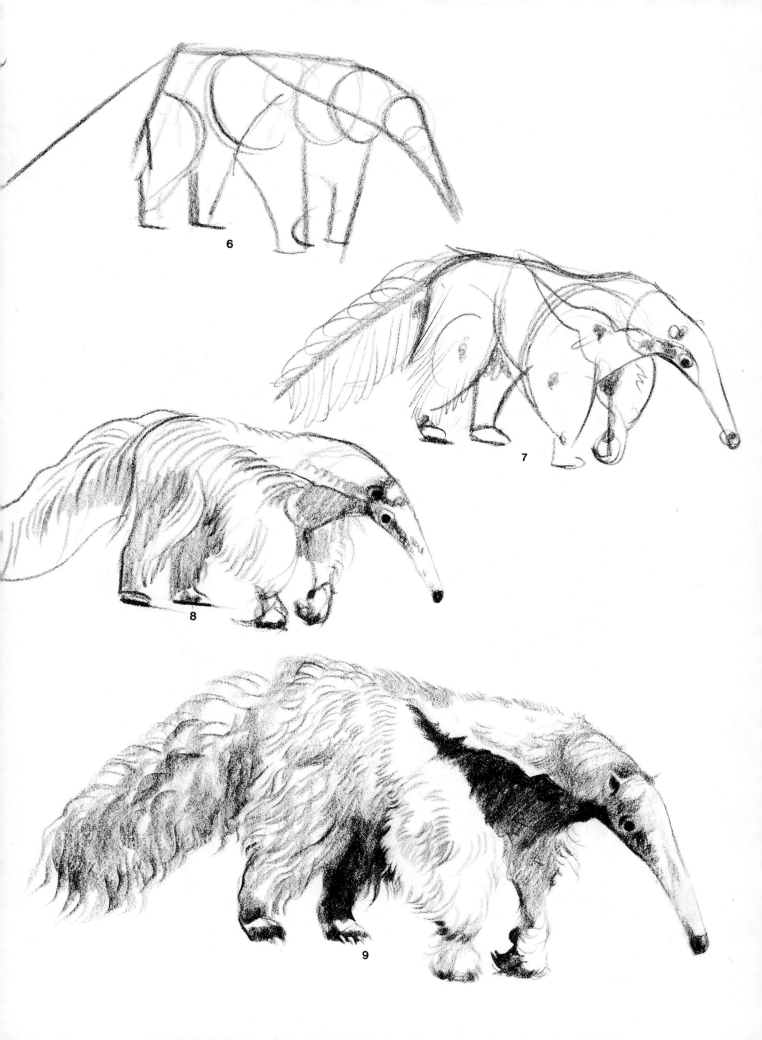

6

7

8

9

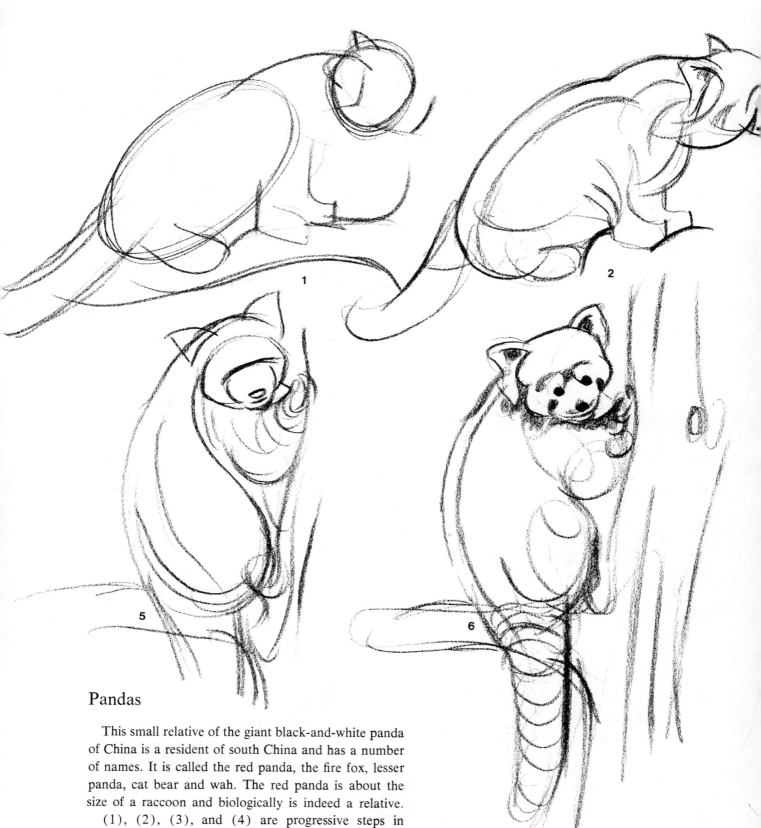

Pandas

This small relative of the giant black-and-white panda of China is a resident of south China and has a number of names. It is called the red panda, the fire fox, lesser panda, cat bear and wah. The red panda is about the size of a raccoon and biologically is indeed a relative.

(1), (2), (3), and (4) are progressive steps in simple profile. In (5) through (6) a more fluid line, other than the oval shape, is the starting point. (8) shows a simple circle beginning, leading to (9).

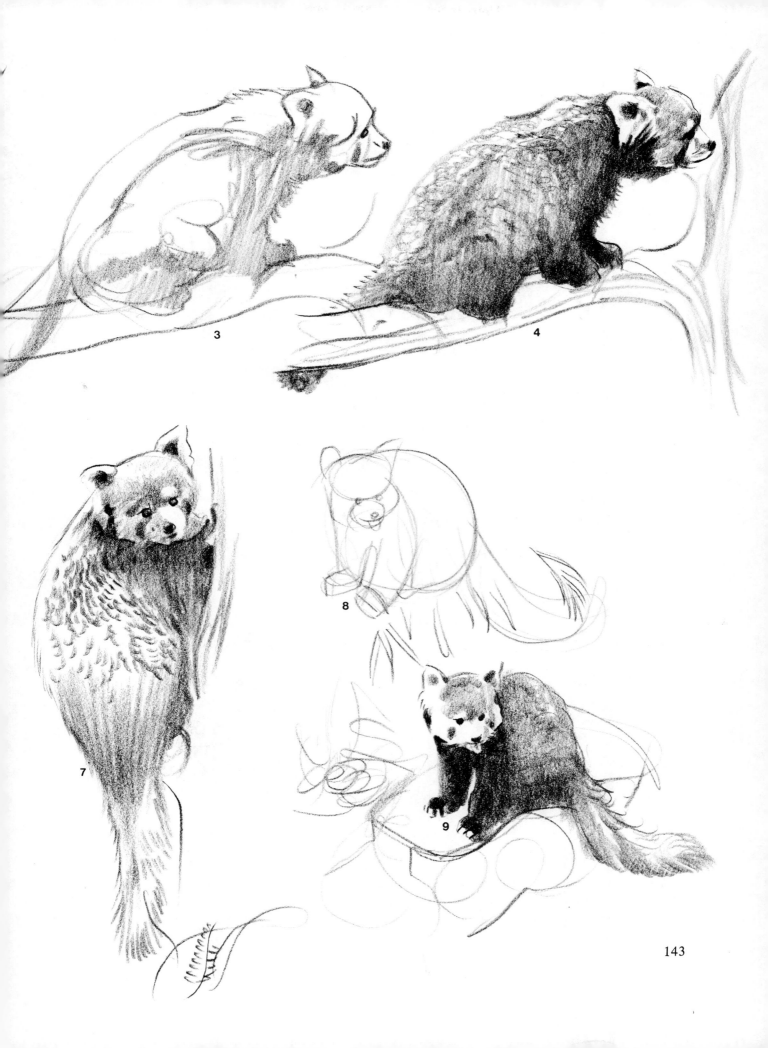

3

4

7

8

9

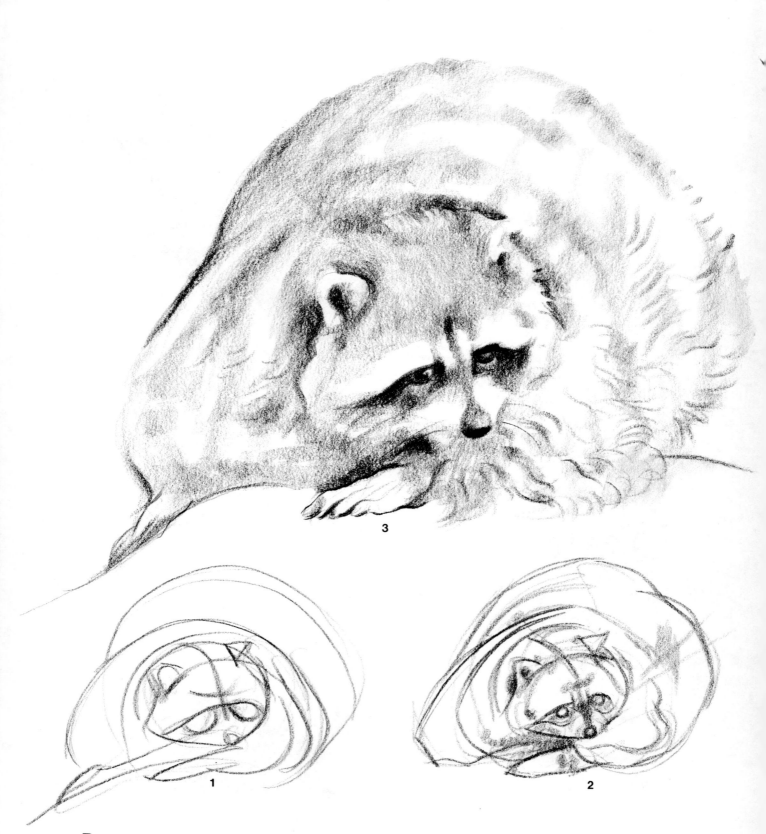

Raccoons

The raccoon chosen as a subject was an extremely active fellow. The animal, in time, settled into a pensive attitude more suitable for drawing. Here in (1) and (2) I show the steps taken to arrive at (3).

This was a large raccoon measuring almost 34 inches from nose to tip of tail.

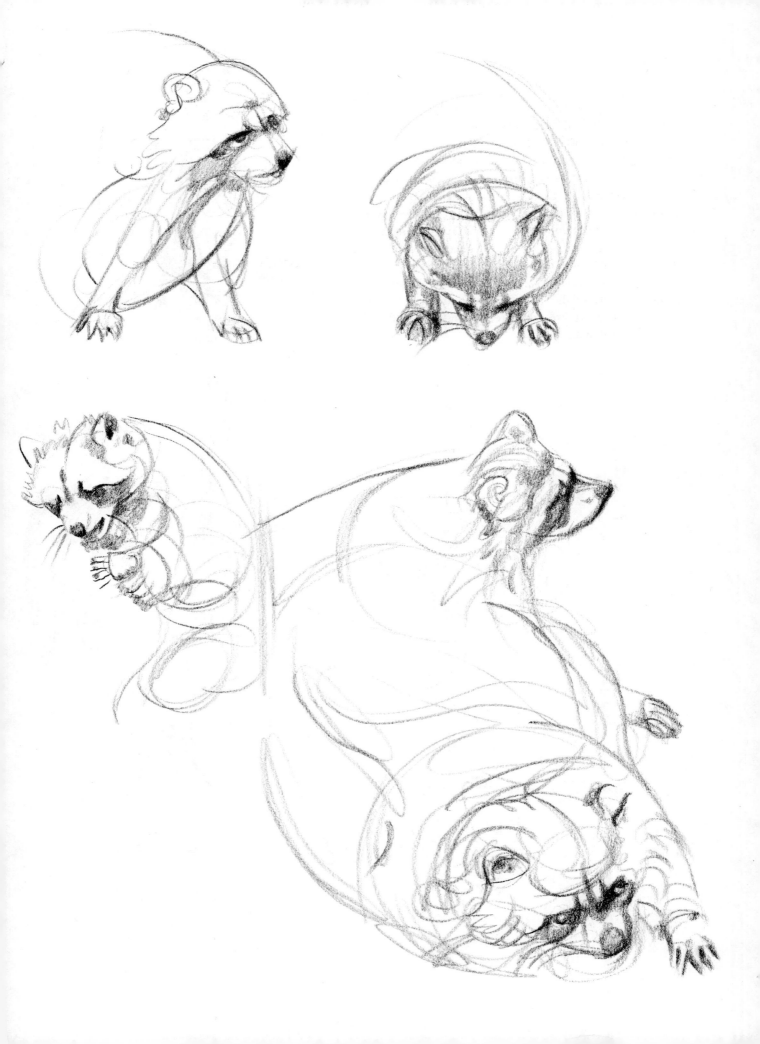

Primates

Although I have avoided, in the early stages of animal drawing, too great an emphasis on the study of anatomy, comparative or otherwise, this is not to say that such study is not important. A practical way to make this phase of becoming an animal artist more interesting is to roughly sketch the skeletons available in museums. A three-dimensional rather than two-dimensional subject is always more effective as an object of study. Write and draw the facts you see . . . the chimp's cranium is smaller than the man's . . . the forehead recedes on the chimp much more than in man. Although chimps are in some cases almost as large as humans their trunk is proportionately smaller. The spinal column of the ape has a single curvature compared to the modified "s" curve in the human.

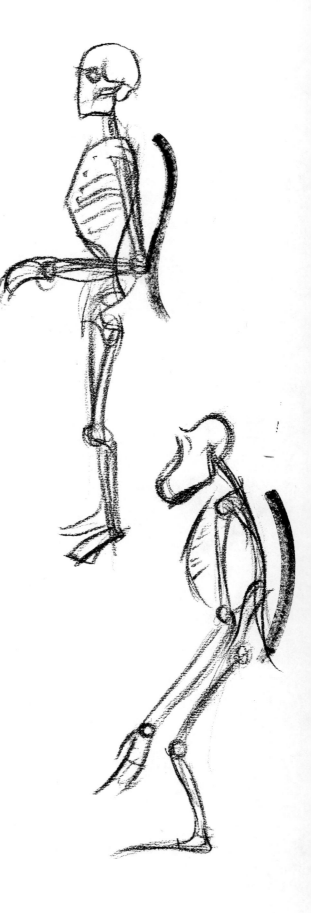

Chimp

Chimp

Human

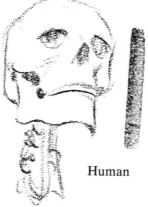

Human

146

Chimpanzees weigh between 120 and 180 pounds and seldom attain a height of more than 5 feet. Note the large ears compared to the gorilla's or the orangutan's.

In sketch (1) the oval has been used to analyze the final line interpretation (2). In (3) the shoulder line has been continued from one side through the head to the other side. The final drawing (4) hides the working drawing construction. In the preceding drawings, and particularly in (5) and (6), the stance and expressions say that the chimps are youngsters.

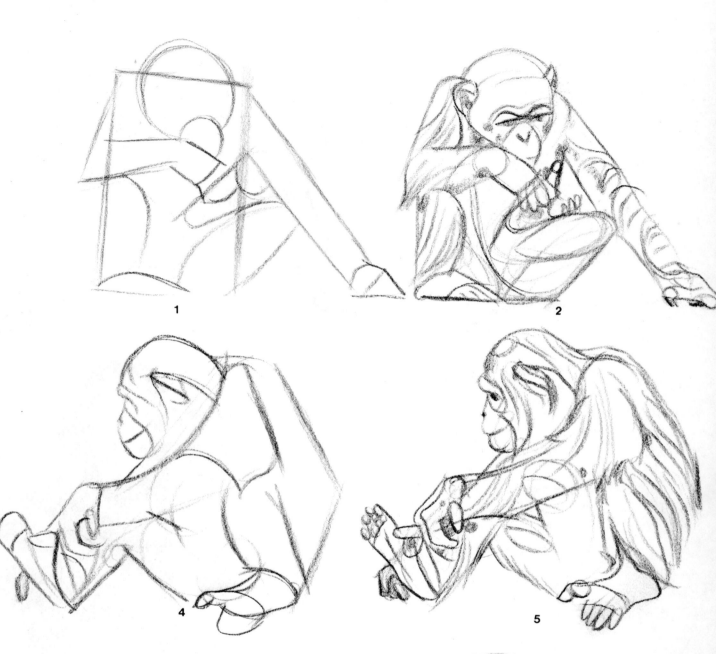

(1) and (2) are recreations of the preliminary work that led to (3). (4) and (5) lead to (6). The strong lines of the thumbnail sketch (7) give a basis for the finished sketch of the seated chimp in (8). Along with sketching the complete animal, spend time concentrating on drawings of parts of the animal, (a), (b), (c), and (d).

148

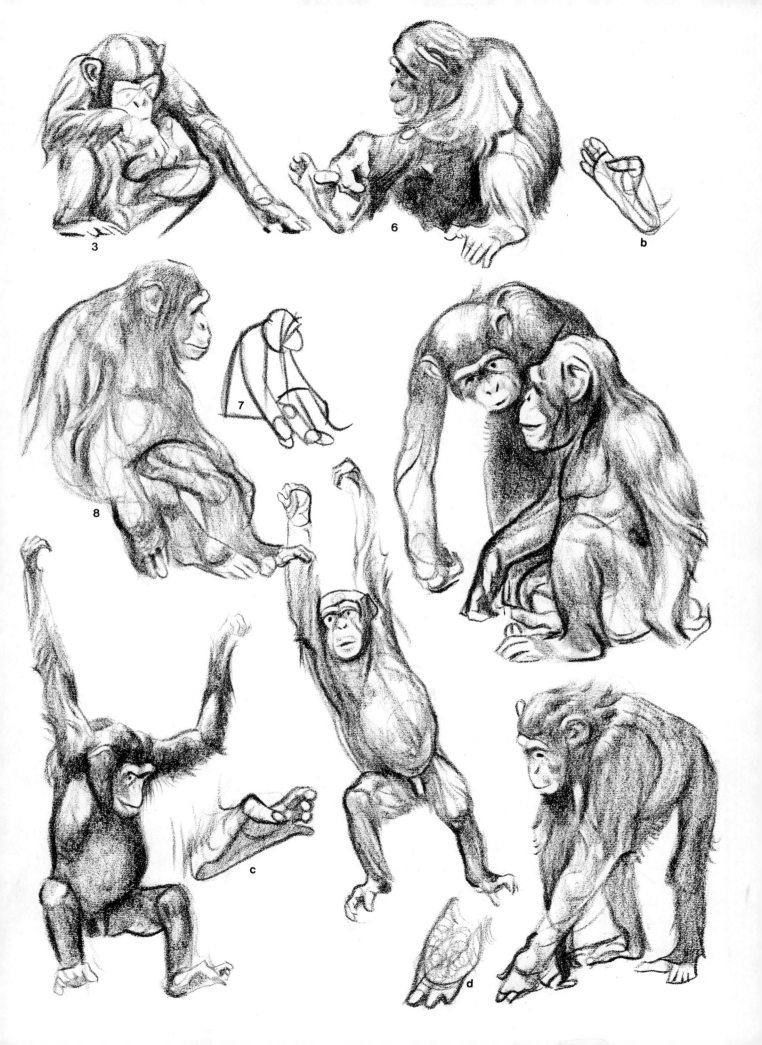

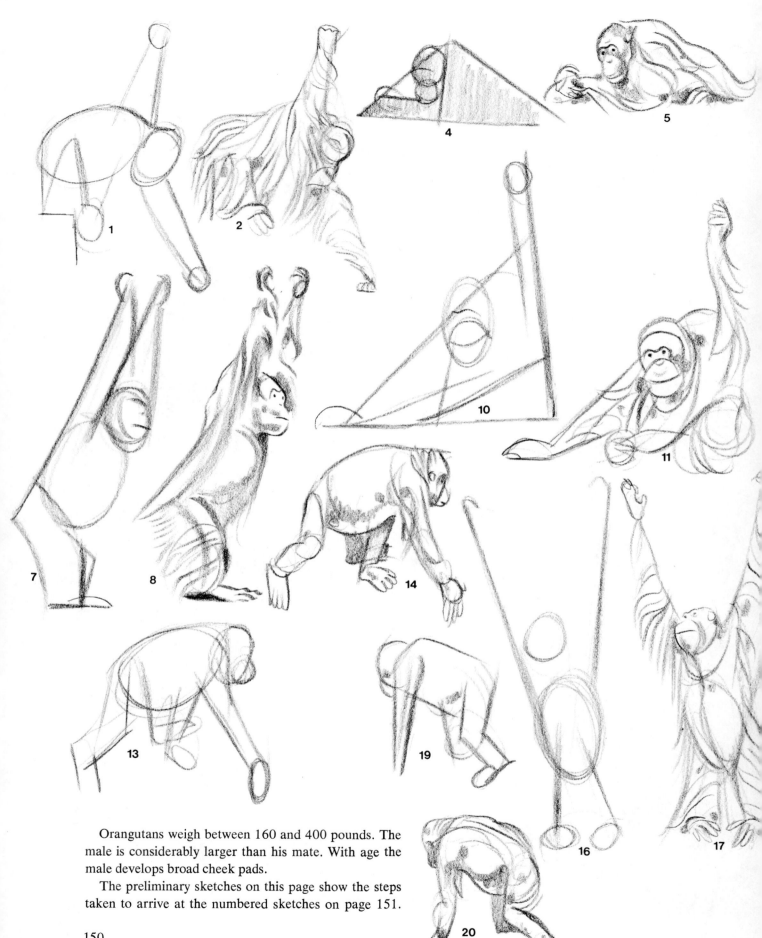

Orangutans weigh between 160 and 400 pounds. The male is considerably larger than his mate. With age the male develops broad cheek pads.

The preliminary sketches on this page show the steps taken to arrive at the numbered sketches on page 151.

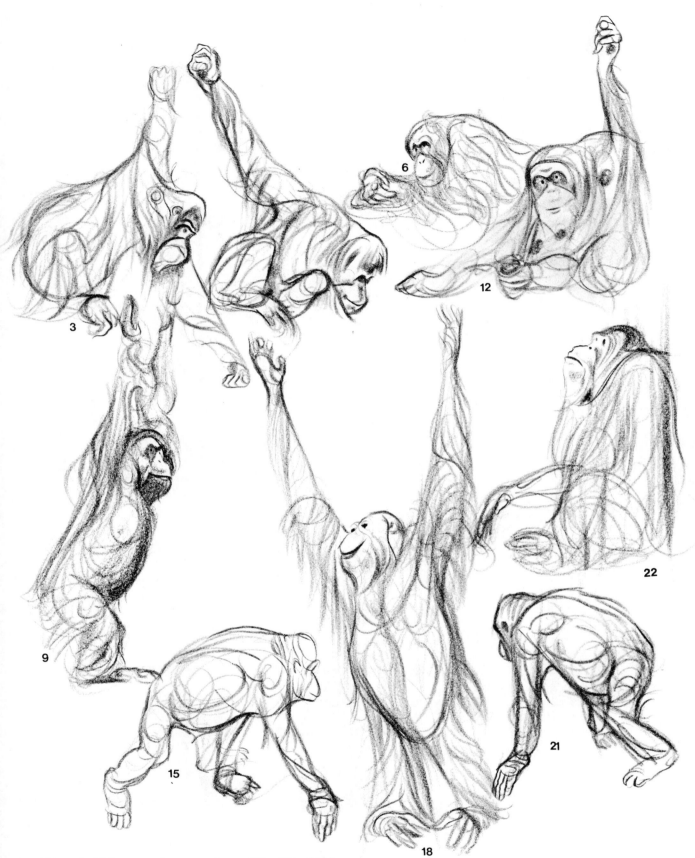

(3) and (12) are male orangutans; (6), (9), (18),
and (22) are female orangutans. (15) and (21) are
fairly young orangutans.

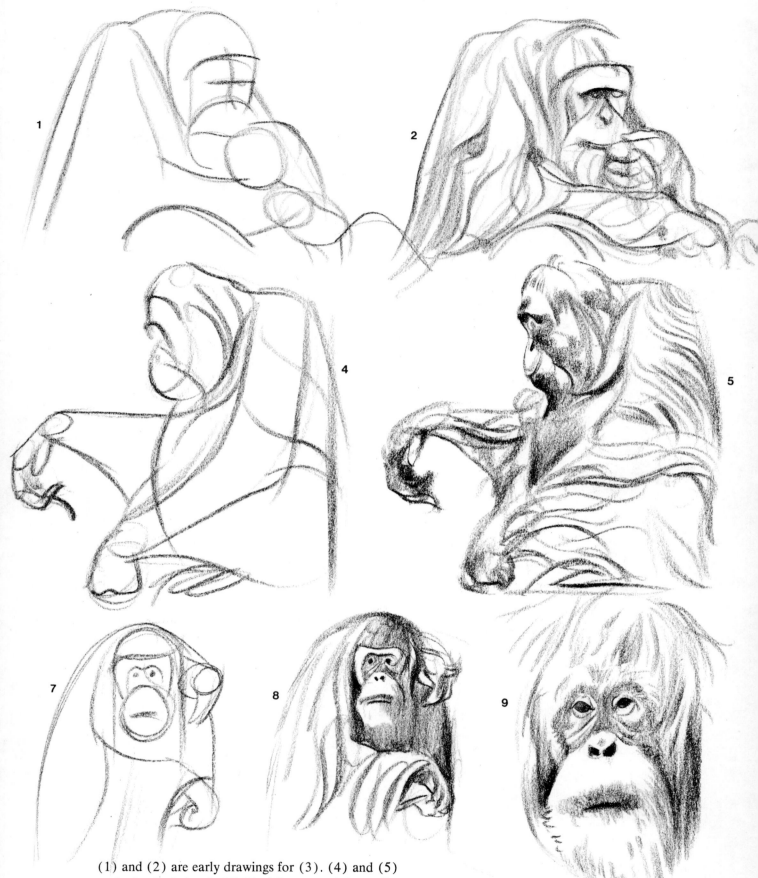

(1) and (2) are early drawings for (3). (4) and (5) precede the final sketch (6). In (6) many of the earlier sketch lines have been eliminated. (7), (8), and (9)

3

6

10

11

are drawings that are the foundation for (10). (11) is one of many sketches of a baby orangutan that finally became the sketch of the youngster with a security blanket on page 154.

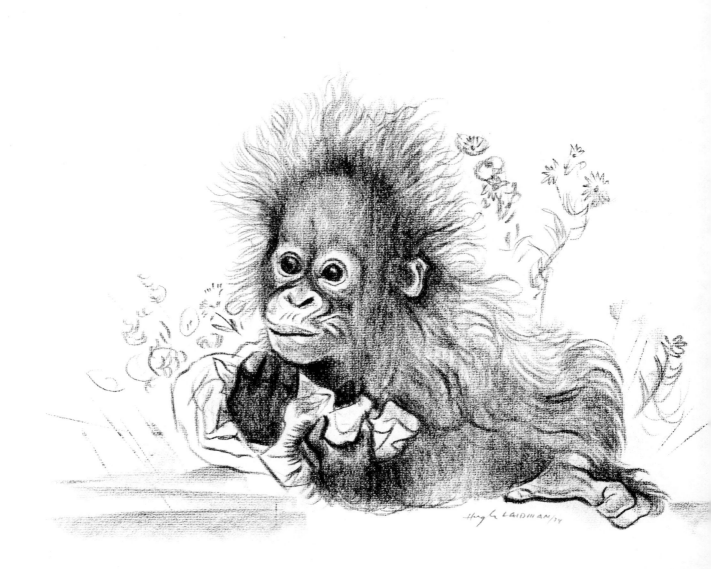

Working drawing 13 x 9 for watercolor *Security Blanket*

The Chacma baboon of South Africa lives 45 years. Its average weight is between 40 and 50 pounds but an old male can weigh up to 90 pounds. Females are considerably smaller than males.

Drawing quick action notes is an excellent way to study any animal.

The seated baboons (1) are carried forward on pages 156 and 157.

It is good practice to select portions of the animal and concentrate on studying the pecularities of its action and form.

1

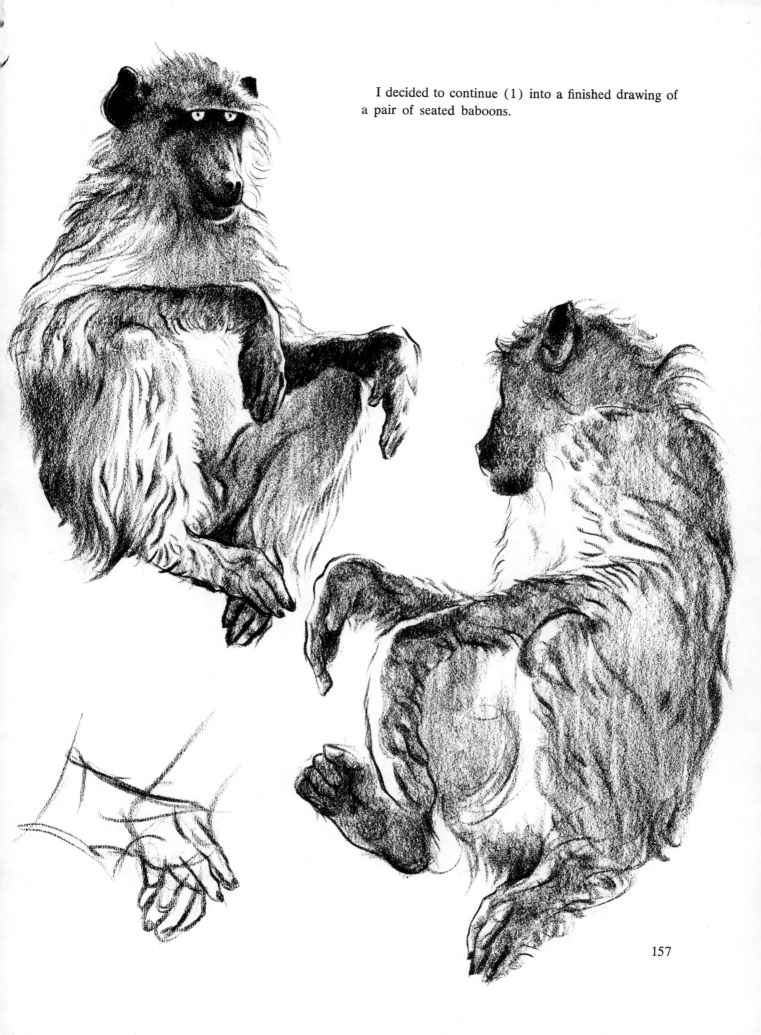

I decided to continue (1) into a finished drawing of
a pair of seated baboons.

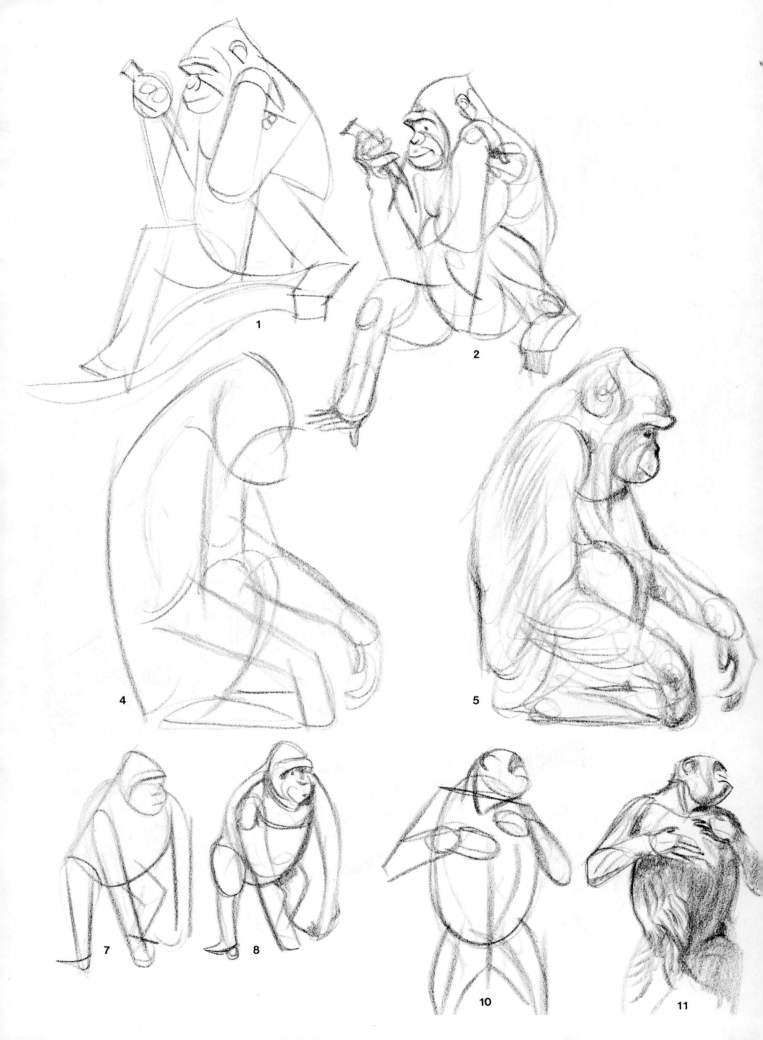

A comparison between gorilla and man aids in drawing either primate. A 6-foot male gorilla will have four times the strength of a 6-foot man. The reach of the gorilla will be over 9 feet, that of a man under 7. The gorilla could weigh 450 pounds, the man 200.

Steps (1), (2), and (3) show the thinking in completing a sketch of an adult gorilla, contemplating a carrot. Steps (4) and (5) precede a less tonal sketch (6). (7), (8), and (9) are an example of the gorilla's typical walking position. (10), (11), and (12) illustrate the gorilla's thumping-the-chest stance; (a), (b), (c), (d), and (e) are baby gorillas.

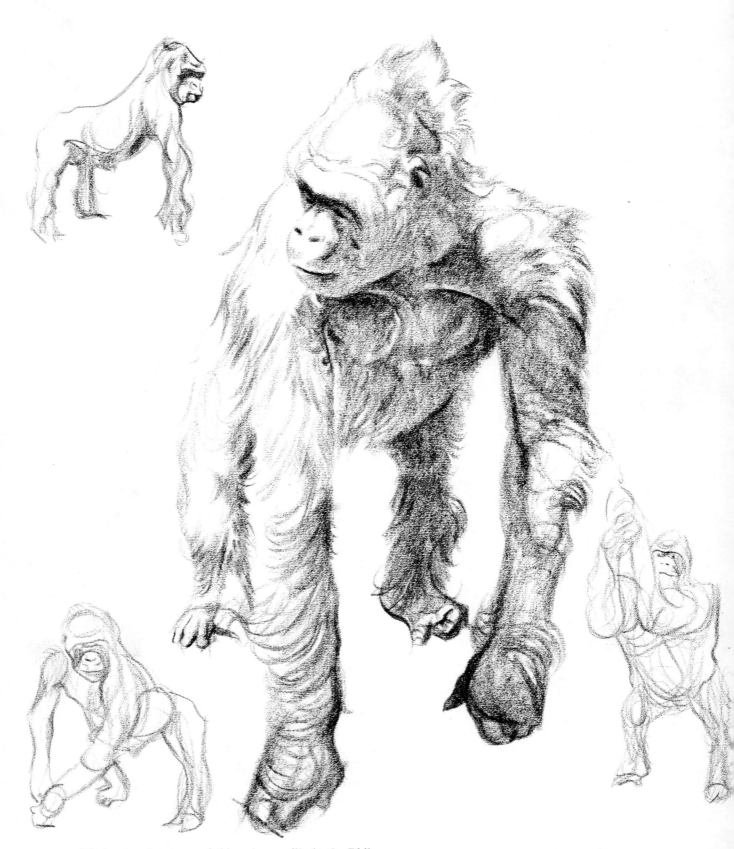

Massa was the name of this aging gorilla in the Philadelphia Zoo. Like an old man, he was balding and his muscles were sinewy and knotty. Unlike an old man, he was extremely active and, for some reason or other, enjoyed falling into football lineman attitudes.

No matter what animal you draw, find out all you can about it so that you will draw more knowingly. Drawing in itself is one of the best ways there is to learn about animals.

160